Grey card (18% tone) Measure the light reflected off this page to obtain average exposure.

THE
PHOTOGRAPHER'S
POCKET
MANUAL

Essential techniques for the photographer on the move

NEW EDITION

JOHN GARRETT

GUINNESS PUBLISHING

First published in 1987 by Guinness Superlatives Ltd.
This new edition published in 1992 by Guinness Publishing
Ltd, 33 London Road, Enfield, Middlesex, Great Britain.

Typeset in Century by Ace Filmsetting Ltd., Frome,
Somerset.
Printed and bound in Italy by New Interlitho S.p.A.

A catalogue record for this book is available from the British
Library.

ISBN 0-85112-517-4

CONTENTS

THE CAMERA

Camera technology has galloped ahead in recent years, each year seeing the addition of a few more auto gadgets. Most of the innovations have been of immense value to photographers: the microchip and printed circuit have changed almost everything.

The camera is still basically a light-tight box with a film holder on one side and a lens on the other. Light is focused through the lens onto the film, thus forming a photographic image.

The modern camera is programmed to produce an average, well-exposed picture in average conditions. It will also produce any result we want, as long as we know exactly what effect we wish to achieve and programme the camera accordingly. The camera is only a machine and cannot take a good picture without a good photographer at the controls. Yet these techniques are more important than the mechanical ones. It is worth recalling all those excellent pictures taken years ago with what we would consider to be extremely basic equipment.

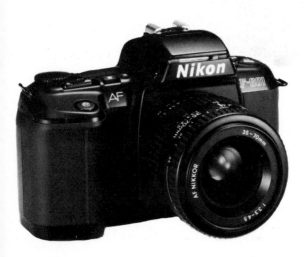

**Nikon F 601
(USA F6006)**
A leader in the high-tech race, it has a dual programme system, auto and manual facilities, autofocus and a built in TTL autoflash.

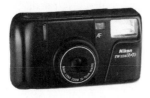

TW Zoom 35–70
One of the numerous
autofocus viewfinder
cameras on the market
("compacts"). Features
include autoexposure,
autoflash, auto film-loading,
film wind, autofocus and a
35–70mm zoom lens.

The autofocus works by
use of an infra-red sensor
and can "see" in the dark. It
is therefore an excellent tool
for taking flash pictures in
the dark. But remember that
this camera's focus point is
only the small area in the
centre of the frame (read the
instructions carefully).

The metering system is
balanced for colour print
film. This is an ideal camera
to use when you are unable
to take all your SLR kit with
you. Carry it in your pocket
or handbag.

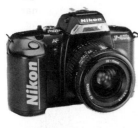

**Nikon F401X
(USA F4004X)**
The Nikon F401X is a good
example of the new
generation 35mm single-lens
reflex camera. It has TTL
(through the lens) auto
(automatic exposure), auto
programmes "P" for normal
shooting and "HI" for high
speed shooting (*see*
Exposure).

The autoexposure is an
aperture-priority camera –
you set the aperture and the
camera sets the
corresponding shutter speed
(*see* Exposure, Aperture and
Shutter). Some cameras are
shutter-priority, which is
equally effective. The F401X
also has an autoexposure
compensation dial, plus
memory lock (*see* Exposure).

These are very important
features for the
photographer who wants
creative control over the
automatic metering system.

The F401X has a built-in
TTL autoflash, designed to
correctly expose flash
pictures. It has autofocus,
autowind, capable of 2.5
frames per second; auto film-
loading and auto 150 (ASA).
Film setting with DX coded
films (see films). The F401X
accepts all Nikon
accessories. The cameras in
this range (Pentax 210,
Canon EOS 1000F, Minolta
3X1 etc.) are good value for
money.

Autofocus is constantly on
the improve, but at present
is still unsatisfactory on fast
moving subjects, especially if
you wish to compose the
subject off centre.

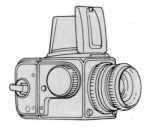

Hasselblad (120 film)
The market leader in 6 × 6cm SLR cameras. Beautifully made in Sweden with a large range of lenses and other accessories. A great favourite with commercial photographers.

Widelux (35mm)
Designed for landscape and group portraits, such as school photos. The 26mm lens moves through an angle of 140 degrees during exposure, producing an image 1½ times wider than the normal 35mm frames. There are 3 shutter speeds: 1/5th sec, 1/125th sec and 1/250th sec. The results are sharp and the contrast brilliant.

Nikonos V
An underwater camera that requires no waterproof housing. Also excellent in adverse conditions such as the sand, rain, humidity, and salt spray, which can destroy equipment. Nikonos is the only camera that can be made sterile. It can shoot on auto or manual and has TTL autoflash capability with a Nikon 88–102 flash gun. A great travel camera (waterproof to a depth of 50m/55yd). Canon (AS6) and Nikon (L35AW AF/AD) have introduced all-weather auto compacts with similar properties to the AF, but they are sealed against sand, spray, cold and heat, and are waterproof to a depth of 10m/11yd – a useful development for the holiday photographer.

Don't economise on a camera bag. Expensive equipment deserves good protection and a badly designed bag makes working very difficult.

Lowe Pro

Comes in several sizes, excellent bag – good protection, good accessibility, waterproof, light when empty, well designed interior. Non-slip shoulder pad and grab handles (important).

Zero Halliburton

Cut out foam provided with the case to suit your own kit requirements. This provides good protection when aircraft storage is unavoidable. A mobile camera cupboard for the hotel room or working from your car. Unsuitable for reportage work.

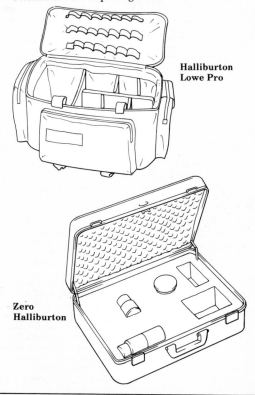

Halliburton
Lowe Pro

Zero
Halliburton

APERTURE

The design of the lens aperture is based on that of the human eye – with a variable opening (diaphragm) that opens and closes inside the lens, controlling the volume of light entering the camera and exposing the film.

The size of the aperture is calculated in f-stops. These are fractions of the focal length of the lens, therefore the higher the number, the smaller the aperture, i.e. f16 may be the smallest aperture of your lens and f2 the largest. If you open up or close down a stop, you will double or halve the volume of light that enters through the lens: f8 lets in twice as much light as f11, and f16 half as much as f11.

The aperture controls the depth of field of the photograph, i.e. the distance in front and behind the point of focus that is in sharp focus. The smaller the aperture, the greater the depth of field (depth of focus) of the picture; for example f16 will give the maximum depth of field of a lens and f2 the minimum (*see* diagram). The creative implications of this are vital.

A scale on the lens barrel indicates the extent of the area in focus at each aperture. The most noticeable effects of aperture control are on long lenses.

Increasing depth of field
If you require a greater depth of field, then you need to stop down by using a smaller aperture. Alternatively, you can move further away from the subject – the closer you are to a subject, the less depth of field you have – or use a shorter focal-length lens (*see* Lenses).
Make sure there is a greater depth of field behind the point of focus than in front (approximately twice as much) – focus one-third of the way down the subject. (See also table on p.45.)

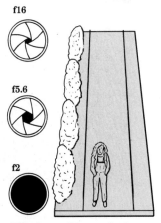

The shot at f2 has no depth of focus – it is a portrait of a girl in an outside environment. The shot at f5.6 has greater depth of field

f16

f5.6

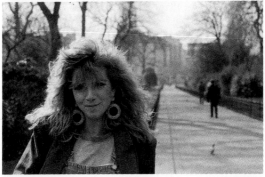

f2

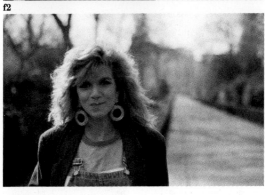

and you can see her environment. The shot at f16 holds focus right through the background and the picture has become an environmental portrait. The choice of aperture depends on what you want to include in the photograph – just the subject or the subject and the environment.

Shot on a 400mm lens at f3.5. The wide aperture in combination with the properties of the telephoto lens has turned the busy leafy background into a soft coloured sympathetic backdrop.

This landscape was shot with the aperture stopped down (f16), to be as descriptive as possible. The foreground, middle ground and background are all sharp.

The wide aperture (f3.5) has drawn attention to the dirty hand, but we can still see that it belongs to a little boy. This is an example of selective focus.

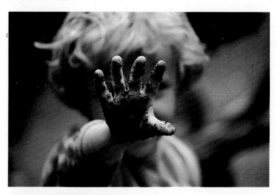

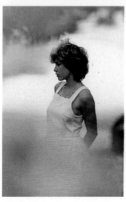

A wide aperture used on a long lens (f3.5 on a 400mm) has made the leaves in the foreground into a soft, out of focus, feminine frame for the girl's face.

SHUTTER

The shutter speed controls the movement of the subject in the photograph. Your choice of shutter speed depends on the degree of movement you want in the photograph and on your need to avoid camera shake (this will apply to telephotos in particular). An exposure time of 1/2000th sec will "freeze" a cyclist so sharply that every straining muscle and facial expression can be observed more clearly than in real life. At 1/30th sec the cyclist will blur across the frame, losing the detail but giving a beautiful impression of movement (*see* illustrations).

Whenever you alter the shutter speed, the aperture must be altered correspondingly (either manually or automatically) so as to maintain the correct exposure.

A cyclist, shot at 1/8th sec, has blurred so much as almost to disappear as an image against the wall.

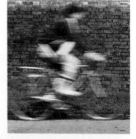

Recommended shutter speeds for various lenses: To avoid camera shake, here are the lowest shutter speeds recommended for each lens.

24/28/35mm	–1/30th sec
50/80mm	–1/60th sec
105/135mm	–1/125th sec
180/300mm	–1/250th sec
400/500mm	–1/500th sec

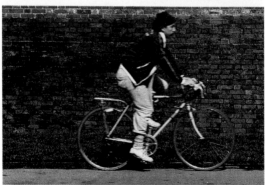

A cyclist moving at normal cruising speed was shot on a 1/250th sec. Note that some blur remains. A 1/500th sec will freeze the movement.

Another technique for photographing speed, or creating an impression of speed, is to pan with a moving subject on a relatively slow shutter speed. Panning means swinging the camera, either from side to side or up and down, in the direction of the subject's movement, at the moment of exposure. Set the shutter on 1/30th sec or 1/60th sec (depending on the speed of subject) and pan smoothly at the same speed as the subject.

Speed	Type of Movement	Camera Distance		Direction of Movement	
Miles/h (Km/h)		Ft	M	↔	↕
5 (8)	Walking	12	4	1/500	1/125
10 (16)	Jogging	12	4	1/1000	1/250
	Horses walking	25	8	1/500	1/125
25 (40)	Running	25	8	1/1000	1/250
	Football	50	16	1/500	1/125
50 (80)	Racehorses	25	8	1/2000	1/500
	Fast cars	100	33	1/500	1/125

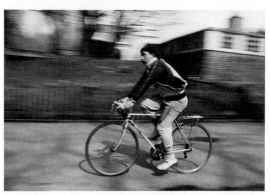

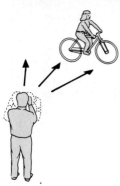

The shutter was on 1/30th sec and the camera panned with the cyclist. The subject held sharp but the background has blurred into speed lines.

The fast shutter speed
(1/2000th sec) has frozen the
hair and the water, giving us
an image impossible to see
with the naked eye.

This little swinger
(opposite) was at the peak of
her movement, so 1/125th
sec held her sharp. If she had
been on the down swing,
1/250th sec would be needed
or, in profile (moving across
the frame), 1/1000th sec.

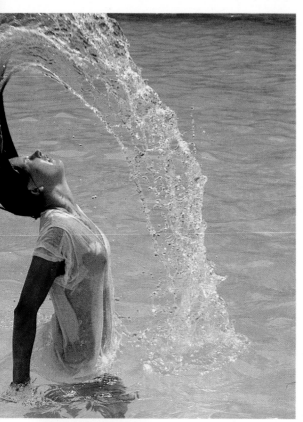

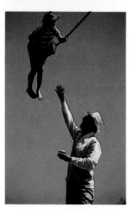

HOLDING THE CAMERA

Most out-of-focus pictures are caused by camera movement (camera shake), by the photographer being off balance and by not holding the camera correctly.

Hold the camera firmly and press the shutter release smoothly. Don't stab at it with your finger. Hold your breath at the moment of shooting. At shutter speeds slower than 1/30 of a second, the camera must be supported – use a tripod, monopod, camera bag or anything else suitable.

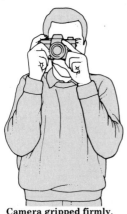

Camera gripped firmly, left hand focusing and supporting the lens, elbows tucked in.

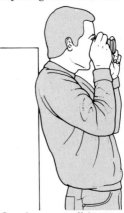

Leaning on a wall for extra support.

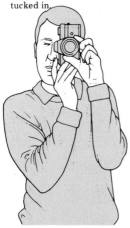

Well balanced, leaning slightly forward, one foot in front of the other.

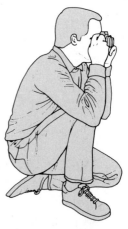

A very solid position, elbows supported on knee.

Before leaving home
Check batteries – take spares.
Do you have enough film? Take two spares.
Do you have the right film?
Do you have a cleaning kit?
Do you have the right accessories for the shoot?
Do you have accreditation if necessary?
Do you have the address of your venue?
Plan a systematic approach to taking pictures: a lot will depend on preparation and care of equipment as on the ability to take a good photograph.
Make sure cameras and lenses are kept separate from darkroom equipment.
Always protect the camera from dust, moisture and heat.

Shooting checklist
Are you set on the correct programme?
Are you set on the correct shutter speed?
Check ISO (ASA) film setting is correct.
Check exposure compensation dial is at zero.
Check shutter speed is correct, if shooting flash.
Open camera and check there is no hair stuck in the shutter gate.
Take up slack on rewind lever. It will rotate if film is winding on correctly.
Check you have correct film loaded.
Always rewind film immediately after finishing it.
Check back elements of lens are clean.
Check you have correct filter mounted.
Make sure the film is wound on before taking a shot.
Check that film speed and shutter setting have not altered between shots.

THE KIT

The question is what to buy at the best possible value for money. Finding your way through all the advertising is difficult. So here are some practical suggestions for how to build up your kit, economically, from your first camera to professional level.

Stage 1

1 camera body with autoexposure and auto-override facilities (exposure compensation dial and memory lock) plus manual exposure facility.
Choice depends on bank balance.
Nikon F4, F801, F601, F401X
Canon F1, EO3100, EOS 1000
Minolta 9000, 3X1, 7X1
Olympus OM4TI
Pentax K1000, P30, Z10
Built-in autowind is useful.
Camera shops include a 50mm lens in the deal. The 50mm is usually the largest aperture lens in the range. Worth taking as your low-light lens.

Stage 2

80–200mm lens (or similar focal length). Independent lens makes are usually cheaper than camera brand names, but be careful as some are poor quality. Tamron SP lenses and Sigma lenses are good.
24mm wide-angle:
good value and obtains real wide-angle effect with very little distortion.
Macro 35–105 zoom (close up):
very useful facility when you are travelling or out and about with one lens.
Tripod (see pp. 22–3).
Camera bag – don't buy a cheap bag.
Expensive equipment deserves good protection (see p. 9).
Filters:
81A, A2 or KR3. Plus Polarizer and ND Graduated Filter (see Filters). Dedicated flash with bounce head and extension cord (see Flash).

Household object accessories

The ordinary, everyday household objects that can sometimes prove useful when taking a good picture with a £1,000 lens:

Swiss Army knife. Small fold-up mirror as a reflector for close-ups. Jeweller's screwdrivers – screws always come undone when you are miles from a repair shop.

Compass – to work out where the light will be at any time of the day. Cotton buds – for camera cleaning. Blue Tac – for sticking gelatine filters to the back of a lens, or pictures on walls, without leaving marks.

Note pad. Araldite glue – safe and strong. Universal electrical plug – for recharging batteries anywhere. Small torch – for reading camera dials in the dark. WD40 – for cleaning the tripod and protecting the equipment (but not the lens) against sea spray etc.

Gaffer tape – repairs almost anything. Vaseline – for cleaning and making soft filters. Space Blanket – compact light reflector.

Stage 3

Second camera body – identical to the first; in case of breakdown; to shoot with two different speed films; to have two different focal lenses shooting on the same job.

300mm telephoto with teleconverter (*see* Lenses).

20mm wide-angle lens.

Stage 4

Underwater camera Nikonos V.

28mm lens to fill gap between 35–105 zoom and 24mm lens.

500 mirror lens plus converter from Stage 2.

55 macro with close-up ring. Second flash gun plus slave unit for multiple flash.

A tripod should be one of your first purchases. Remember that most out-of-focus pictures are caused by camera shake. Tripods are essential when shooting with long telephoto lenses. They allow you to take pictures that would otherwise be impossible, such as nightscapes. I always use a tripod when taking portraits – the sitter has a constant source of reference and I can "conduct" the sitting. Sharper pictures can be achieved with a cheap camera on a tripod than with an expensive one in shaky hands.

Lock the mirror up if your camera has the facility, as the bounce of the returning mirror can cause camera shake.

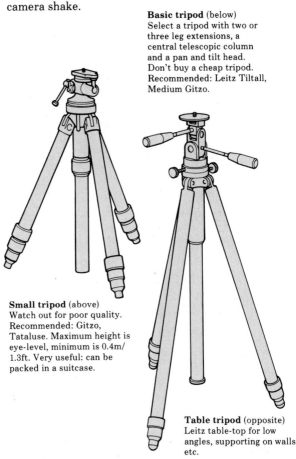

Basic tripod (below)
Select a tripod with two or three leg extensions, a central telescopic column and a pan and tilt head. Don't buy a cheap tripod. Recommended: Leitz Tiltall, Medium Gitzo.

Small tripod (above)
Watch out for poor quality. Recommended: Gitzo, Tataluse. Maximum height is eye-level, minimum is 0.4m/ 1.3ft. Very useful: can be packed in a suitcase.

Table tripod (opposite)
Leitz table-top for low angles, supporting on walls etc.

Clamps can be used to fix cameras in difficult corners. If fixed to a solid object, the camera will be steadier than a tripod. Most screws used are ¼ inch whitworth. Build up a set of clamping accessories: Stanley straps to go round trees (right), spring clips for attaching to shelves (left).

Monopod
Used by sports and news photographers to support long lenses.

Bean bag
Any bag ¾ filled with beans or comparable material – use for shooting out of car windows, on top of car roofs (safari) and all uneven surfaces (stone walls).

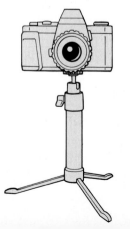

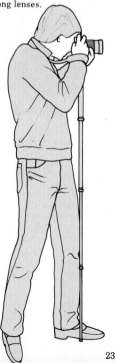

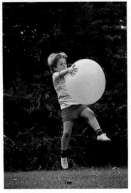
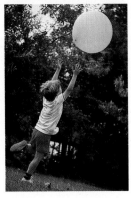

Motor drive sequence
(above)
Often a sequence is more effective than a single frame – especially of lively action. The motor has now made a former arduous task much easier. Practise your technique of following the focus of a moving subject – often necessary when shooting a sequence.

250 Exposure back with motor drive (opposite, centre)
The Nikon F3, when fitted with the MD4 motor drive and the 250 exposure back, is capable of 5 shots per second. In combination with the 250 exposure back, bulb loaded, it is excellent for sport, news and surveillance photography.

Modulite remote control unit (opposite, bottom)
The hand unit emits an infra-red beam to the receiver mounted on the camera's hot shoe, which triggers the camera shutter. Two remote cameras can be fired from one transmitter. The photographer can frame up a picture and then shoot from a concealed position. Ideal for wildlife, the home, racing, state occasions.

Cable Releases are essential when making a long exposure with the camera on a tripod. They eliminate camera shake caused by shaky hands.

Air release cables (left) can be as long as 30m/98ft whilst motor drive releases (right) can only be used at a distance of up to 5m/16ft.

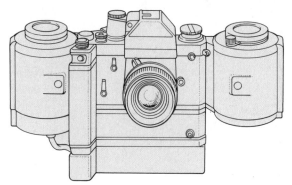

Nikon F3 with MD4 motor drive

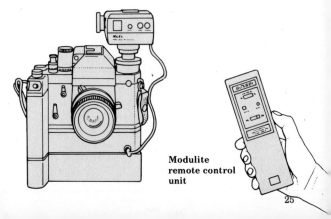

Modulite remote control unit

Loading film

1. Film speed is denoted by an ISO or ASA number: set the film speed dial to this number.

2. Place the film in your camera, and advance the film using the lever until both sprockets are on the drive gears.

3. Close the back of the camera; wind on the film, using the film lever and shutter release until the film frame counter reaches one. Make sure the rewind knob turns when you wind on; this checks that the film is being wound from the spool.

Unloading film

1. To unload film, press in the rewind button on the base of the camera; unfold the rewind knob and turn until the film is completely rewound.

2. Pull up the rewind knob; this will release the camera back.

3. Remove film and put it in its plastic container, write a label with any processing instructions and keep separate from unused film.

Camera care

1. Never leave your camera in the hot sun.
2. Use a filter to protect lens.
3. Use Kodak liquid lens cleaner on a lens tissue for cleaning lens. Back elements of lens are most important – they affect the focus more than front elements.
4. Cotton buds for cleaning mirror and viewfinder.
5. Toothbrush for fiddly bits.
6. WD40 for cleaning tripods and metal cases, using a drop on a piece of tissue. Wipe over camera body (but not inside of camera or lenses) after the camera has been exposed to salt water.

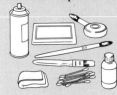

7. Sable brush – useful for most areas.
8. Read your camera manual *carefully*.

Cleaning lenses

It is best to gently rub the lens with a chamois leather, dipped in Kodak liquid lens cleaner. Do this only after dust-off has failed. In some parts of the world dust can be so fine that only fluid will remove it. Check that the film path is clean (see below), otherwise particles of dust will scratch the film.

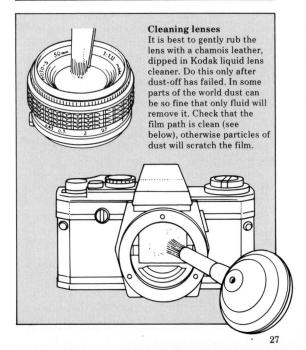

A film is chosen for both practical and creative reasons. Select a film with an ISO rating appropriate to the amount of light available, so that you can shoot by hand while maintaining the shutter speed and aperture that you require.

The choice depends on whether you want sharp, high contrast, grain-free pictures or a grainy, soft effect. For example, two photographers are shooting the same landscape: one may want to reproduce every blade of grass and uses Kodachrome or a 50 ISO film; the other may see it as an Impressionist painter would – soft, grainy and romantic and uses 1000 ISO film.

The slower the film speed, the greater the sharpness, the smaller the grain structure and the greater the contrast. The faster the film speed, the softer the contrast and resolution (sharpness) and the larger the grain structure.

Most transparency films (except Kodachrome) can be upgraded, i.e. EKTA EL from 400 ISO to 800 ISO or even 1600; FUJI 100D to 200 ISO. You must mark the film "+1" or "+2" which will indicate to the laboratory that a "push" or 1 or 2 stops is required in development. Pushing film speed increases the grain structure and the contrast. I wouldn't recommend pushing slow films such as 50 ASA because you are destroying the properties for which they are chosen, i.e. extreme sharpness and fine grain. Unless you are using grain for a creative effect or can't take the picture any other way, it is best not to push film; use a faster film instead.

Increasing Film Speed
Most auto-electronic cameras are balanced for colour negative film – to give the liberal exposure required for a negative. I always underexpose all colour transparency films to be sure of a well-saturated transparency (strong colour).

64 ASA	to	80 ASA(ISO)
100 ASA	to	125 ISO
160 ASA	to	200 ISO
200 ASA	to	300 ISO
400 ASA	to	500 ISO
640 ASA	to	800 ISO
1000 ASA	to	1250 ISO

Film Handling

Films deteriorate with time – colour films in particular. Colour balance and film speed are adversely affected by heat and humidity. Films should ideally be stored in a refrigerator. Before use, return them to room temperature slowly, and develop as soon as possible after exposure. Deterioration accelerates after exposure.

To protect films from humidity, wrap in kitchen foil. Check date of film when purchasing it. In extreme heat, pack film in a Kodak insulated film bag (very cheap) with a freezer sachet. Open and close only when loading camera – film will remain cool all day.

Films are affected by X-ray machines in airports (especially exposed films): 1000 ISO is most vulnerable. If they are subjected to this several times (as on long trips), ask for hand searches.

Loading cassettes from bulk film cans (available in 30.5m/100ft lengths) saves considerably on film costs (nearly 50%). A bulk loader is useful, but be careful of grains of dust – if caught in the cassette they will scratch film.

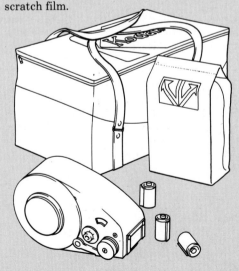

The great joy of black and white photography is to watch a print magically appear in the developer. I see no point in shooting black and white films without developing and printing them as well, because a great deal of the creative input lies in the dark room.

Tip: As a guide to how colours transpose into grey tones, switch from colour to black and white on your TV and back again.

Black and white films can be pushed considerably, but then you are only developing up highlight, not shadows. If you want shadows, you must expose for them. Pushing is suitable for photography at concerts, parties, football games.

Black and white films fall into 4 groups:

1. *Slow speed:* 25–50 ISO. Fine grain and very sharp e.g. Agfapan 25; Ilford PAN F (50 ISO); Kodak Panatomic X. Ideal for the ultimate quality and large prints.

2. *Medium speed:* 100–160 ISO. Kodak Plus-X; Ilford FP4 plus; Agfapan 100. All-purpose group, fine grain and sharp. Kodak T-Max 100.

3. *Fast speed:* 400 ISO; Ilford HP5 plus (400 ISO pushes to 2400); Kodak Tri-X (400 ISO); Agfapan 400; Kodak T-Max 400. Very useful group. More grain than 1 or 2 above but not oppressive. Good tonal range, ideal for photojournalism in all conditions; all push to 800 ISO comfortably.

4. *Very fast speed:* for low light conditions, sport or grainy effect. Kodak T-Max 3200 can be pushed to 6400 ISO which is a big advance in low light film; it is sharp and with good shadow detail (must use T-Max Developer); Fuji Neopan 1600 can be pushed to 3200 ISO or even 6400 ISO.

You must mark your ISO rating on the cassette. Pulling the development time of black and white films achieves a negative with less contrast from high contrast light conditions.

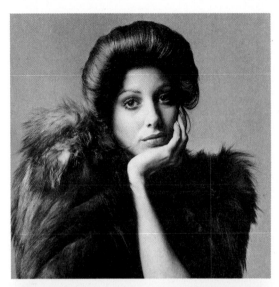

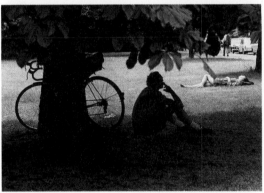

Portrait (top)
Shot on Hasselblad (6 × 6cm), using FP4 film. The fine grain and smooth texture is in keeping with this smooth, classy lady. The slow films are very sharp (note the eyelashes). A similar result can be achieved on 35mm by using PAN F of Panatomic X, processed in a fine grain developer.

Man under tree (above)
Typical general reportage subject for the 400 ISO group of films. It is known as the press photographers' film, because of its great latitude; its tonal range when several different lighting conditions have to be taken on the one film, and its potential for being uprated to 800+ ISO.

FILM/3

Colour films are balanced for either daylight or tungsten light. Tungsten light is more orange than daylight and so tungsten film has a blue cast to balance this.

Daylight film is also balanced for electronic flash and blue flash bulbs. It will produce an orangey transparency when shot in tungsten (light correction filter 80A) and a greenish transparency when shot in fluorescent light (correction filter FLD).

Shot on Ekta EL 400 (opposite right). The tungsten light has produced an orangey colour on the daylight balanced film.

Shot on Ekta EPT 160 (opposite left). The tungsten balanced film is the correct combination with tungsten light and produced an accurate colour rendering.

Colour Negative Film

Kodak Ektar 25 Almost grain-free, prints at any size, very sharp, good colour saturation.
Kodacolor Gold 100 Fine grain, sharp, good colour saturation wide exposure latitude, excellent skin tones.
Kodacolor Gold 200 Faster than Gold 100 but with similar properties.
Kodacolor Gold 400 High quality fast film. Similar characteristics to Gold 100 and 200.
Kodacolor Extra Press 1600 Ultra fast and excellent for indoors without flash; grainy effect can be attractive.
Fujicolor Reala 100 Excellent colour saturation (especially good skin tones), very sharp. Good in mixed light sources.
Fujicolor 200 Excellent all-round everyday film.
Fujicolor 400 Fast but with fine grain, good in mixed light sources indoors.
Fujicolor HR 1600 Very fast, excellent in low light – no flash required.
Agfacolor XRS 100 Good competitor to Fuji and Kodak 100 films. Similar properties.
Agfacolor XRS 200 Excellent all-round everyday film.
Agfacolor XRS 400 One of the best fast print films. Good exposure latitude.
Agfacolor XRS 1000 Excellent low-light indoors (no flash) film. Holds good shadow detail.

Transparency films

Kodachrome 25 Sharpest and finest grain structure on the market.
Kodachrome 64 Similar properties, but more versatile than K25, not as good skin tones however.
Ektachrome RN 100 Excellent all-round transparency film. Good skin tones. Better for sea and sky than Kodachrome.
Ektachrome 200 Good all-rounder – coarser grain than 100 ISO films.
Ektachrome 400 Performs well in low light but lacks colour saturation in fine conditions.

Ektachrome P800/1600EES Push film can be rated 800, 1600, 3200 ISO. Best at 1600.
Fuji Velvia (50 ISO) Outstanding fine grain (compares well to Kodachrome) but better all-round colour saturation. Very sharp.
Fujichrome 100D Bright, saturated colours, excellent warm skin tones, best film for dull lights (colourwise).
Fujichrome 400D Good all-round fast film relatively fine grain, good colour saturation. Pushes well.
Fujichrome 1600 Can be rated at 400, 800, 1600 or 3200 ISO. Excellent results in bad light conditions (glaring).
Agfachrome 50RS Good competitor to Kodachrome but warmer colour balance.
Agfachrome 100RS Good all-round film for portraits.
Agfachrome 200RS Good alternative to Ekta 200.
Agfa 1000RS Softer colour and grain than Fuji 1600. Used for beautiful painterly effect at 2000 ISO.

Artificial Light Film

Kodachrome 40 (Type A) Balanced for photoflood at 3400K. Same qualities as daylight Kodachrome S. *Only available USA.*
Ektachrome EPT 50 Sharp, fine grain, good colour saturation.
Ektachrome EPT 160 Grainier than EPT 50 but good colour. Suitable for push to 600 ISO. (Increases grain.)
3M 640T Grainy but useful fast artificial-light film.

Special Films

Ektachrome Infrared Sensitive to infra-red light. Colour unpredictable. Recommend research, but results can be fascinating.
Kodak Photomicrography 2482 Special high-contrast colour film for microscope photography. 16 ISO. Very high resolution.
Polaroid Polachrome 35MM Using portable autoprocessor produces instant transparencies. Results unpredictable.
Agfa Diadirect 32 ISO A black and white transparency film of very high quality.

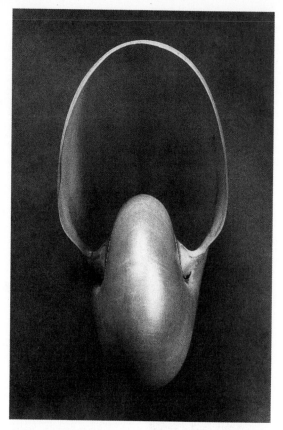

Many committed photographers consider that black and white is the only true medium for photographic art. They say that colour distracts the eye from form and content. I agree that working with light, shade and form in black and white is a great joy, but at least 50% of the result depends on the darkroom technique. So, unless you develop and print your own pictures, there is really no point shooting black and white film at all.

These three photographs were all shot for the black and white quality and would be weaker if shot in colour.

The shell (above)
This is an exercise in light. It is shade and form lit from a window with a white reflector opposite the window. HP5 film.

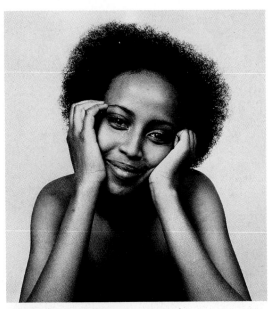

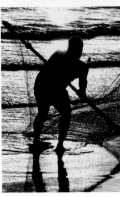

Portrait
Made on FP4 in a Hasselblad
(6 × 6cm). The composition
is simple: black and white
adds a great strength and
dignity to portraiture. Think
in tones not colours.

Fisherman
Ideal situation for B&W – a
dark strong shape with
horizontal and diagonal lines.
A red filter lifted the
contrast, removing the mid-
tones. HP5 film.

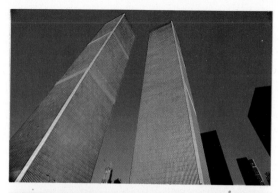

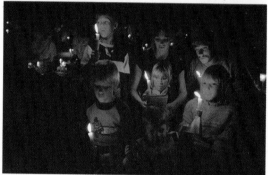

Slow colour
This architectural subject is ideal for Kodachrome 25. Kodachrome produces the ultimate in sharpness and hard-edged colour. Stronger in the reds than the blues.

Candle light
Carols by candle light in Melbourne. This sort of shot would have been difficult a few years ago. The 3Ms 1000 has made it routine. Rates at 2000 ISO without ill effect (slight increase in grain). Fuji 1600D and Kodak P800/1600 FFs are excellent also.

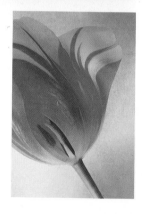

Flower
The extremely fine grain and sharpness, coupled with the great colour saturation, makes the slow E6 processed films ideal for ultimate detail and punchy colour. Shot on Fuji Velvia (50 ISO).

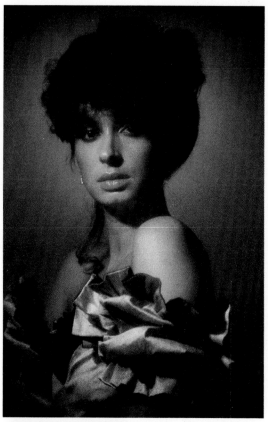

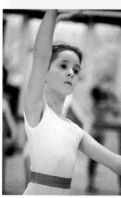

Girl
The fast film (3Ms 1000 ISO
pushed to 3000 ISO) was
used for its soft, grainy
artistic qualities. Experiment
with this range of fast films.

Ballerina
Taken on Fuji 400D. This
group of films is ideal for
shooting available light
indoors. They can be
upgraded to 800 ISO without
being badly affected. The
colour quality is excellent in
low light.

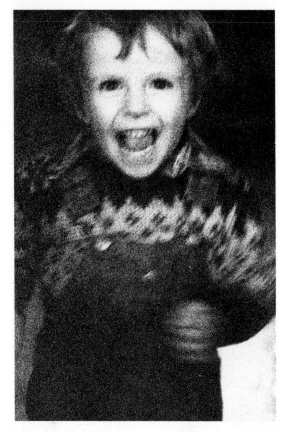

Boy running
Shot on Kodak Recording
Film 2475 in a very low light.
This film gives a coarse grain
structure but this can add to
the effect of excitement.

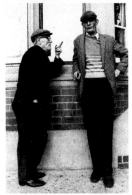

Two men talking
400 ISO film is used by press
photographers because of its
enormous versatility. It is
possible to shoot in
numerous light conditions on
the same film and still
produce satisfactory results.

Ultra-fast films are useful for working in dark, dim interiors and night time events. It is a very grainy film but the grain pattern can be used to give strong graphic effect.

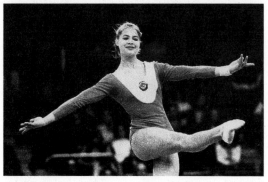

The gymnast
Gymnasts go through all the routines quickly, so shoot continuously, preferably with motor-drive. Use a very fast film: 1000–1600 ISO.

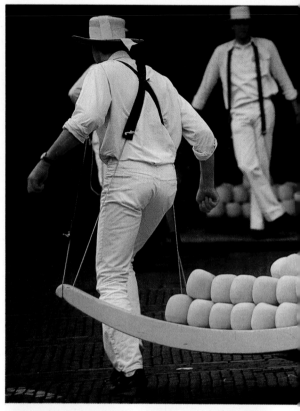

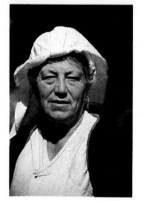

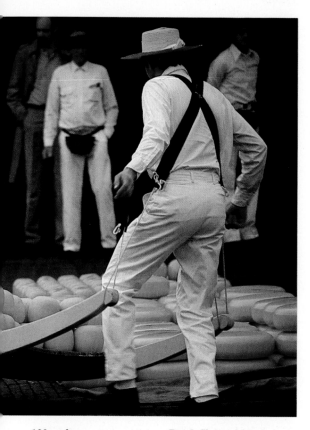

100s colour
Seychelles (opposite left)
The blues of the sea are ideal
for the E6 100s. This is shot
on Ekta EN. I always use
Ekta EN or Fuji 100D at the
beach or for big sky shots.
Can be upgraded to 200 ISO
quite effectively.

Greek Lady (opposite right)
The skin tones shot on this
group of films are excellent –
especially Ekta EN and Fuji
100D.

Dutch Cheese (above)
The weather was grey and
dull but the Fuji 100D has
produced bright clean whites
and saturated yellow (helped
along with an 81A filter).
This group with warming
filter (*see* Filters) handles
dull light well.

EXPOSURE

A photograph is correctly exposed when the aperture and shutter combine to expose the negative or transparency for maximum detail, colour saturation or tonal gradation (black and white).

Whether you take the exposure reading using the TTL metering of your camera set on "Program", "Auto" or "Manual", or use a hand meter and set the camera manually, you still have to decide how you want the picture to look. What feature in the frame do you want to expose for?

Modern cameras with automatic exposure programmes have been brilliantly designed so as to produce average, well-exposed pictures in average conditions. Conditions vary, however, and photographers do not always want an "average" picture. They may wish to emphasise high lights, or to create a dark, moody picture, or a light, wishy-washy high-key (shadowless) picture. The auto cameras will achieve these results, but only if we instruct them accordingly. The question of what exposure to give the photograph is a creative decision, not just a technical one.

Equivalent exposures

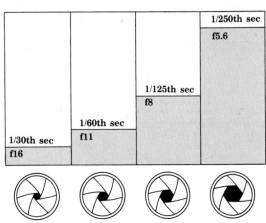

| 1/30th sec | 1/60th sec | 1/125th sec | 1/250th sec |
| f16 | f11 | f8 | f5.6 |

TTL Metering
It is essential that you are aware of which system of TTL metering your camera uses. I prefer a 60%/40% system; the 80%/20% weighting used in some cameras is too specific. 60%/40% takes a more general reading and produces better all round exposures.
1. Automatic multi-pattern metering reads each segment, then decides on an optimum overall exposure.
2. 60%/40% centre weighted metering: the reading is biased towards the central area. Some cameras are also 80%/20%.
3. Spot reading exposure taken from the centre.

Grey card readings
Camera and hand meters are designed to produce an exposure of any subject to the density of an 18% Kodak Grey Card. (*See* inside cover.)

Readings taken off a grey card are very reliable in difficult light conditions (i.e. high contrast, snow etc).

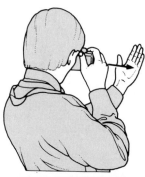

Reading from hand
Useful if subject is a long way from the camera or meter and perhaps surrounded by a very dark or light background. Place your hand in a similar light to the subject, set camera manually, or use memory lock, and then shoot picture. Take a second shot at one stop over to be sure of success.

43

A
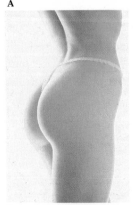

B
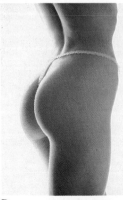

C
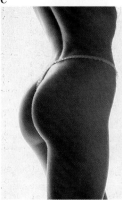

D
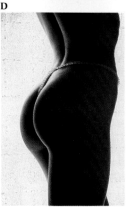

All four exposures are correct – dependent on what result you are looking for.

A is overexposed by 1 stop. The picture now has a softer feeling and the backlight has broken into the edges of the girl's legs; all background detail has gone.

B is shot on the meter – the camera's correct exposure. There is a good compromise of detail in the background and flesh tones.

C is underexposed by 1 stop producing a darker, more graphic picture.

D is underexposed by 2 stops. The picture is dark and moody.

By bracketing you can often produce a great and unexpected result. You should bracket in 1/2 stops to be safe.

When an exposure meter takes a reading of a subject at a given light value, it will show a range of shutter and aperture combinations. The one you choose depends on whether your priority is depth of field (controlled by the aperture) or control of movement (by the shutter).

f2.8	—	1/1000
f4	—	1/500
f5.6	—	1/250
f8	—	1/125
f11	—	1/60
f16	—	1/30

Most serious photographers use independent hand meters as well as, or instead of, TTL camera metering.

If you need to know the exposure value in every area of your picture, a hand meter is essential.

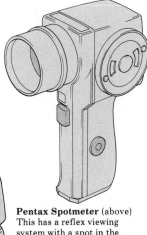

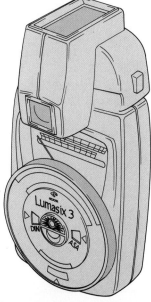

Pentax Spotmeter (above) This has a reflex viewing system with a spot in the centre that takes a 1 degree angle reflected reading off the chosen subject from a considerable distance. It is used when the photographer's position is fixed and he has no opportunity to make close up readings, such as at the theatre, sporting events, and where the subject is against a very dark or light background.

Grossen Lunasix (Luna Pro) (left) A versatile and accurate meter in extremely bright or low light conditions.

Light source
reflected off
subject

Reflected
reading

Incident
reading

Light source

Incident and reflected light readings

Reflected light readings are taken from the light that bounces back off the subject (TTL meters work on reflected light); incident readings are taken from the light falling onto the subject: hold the meter in front of the subject and angle towards the camera (with incident diffuser cone in place). Incident readings are advisable when bright light is bouncing back off brightly reflected surfaces (as on the beach, at sea, in snow, with windows reflecting the sun). Such conditions produce underexposed reflected readings. Reflected readings are best for most general lighting conditions.

Film speed dial
Setting for ISO (ASA) film speed can be used to override auto camera, i.e. 100 ISO film at 200 ISO to underexpose by 1 stop. Set 100 ISO film at 50 ISO to overexpose by 1 stop. Use when camera has no other override method, or when you are pushing whole film (e.g. 400EL to 800 ISO).

Exposure compensation dial
For over- or underexposure on auto, up to 2 stops either way in ⅓ or ¼ stops. Use for fine tuning your exposures, for creative control of exposure.
REMEMBER TO ZERO THE DIAL AFTER EACH SHOT.

Memory lock
Take close-up reading with camera, lock the exposure, then back off and compose the picture. For use in uneven light conditions and when your subject is not composed in the centre of the frame.

Backlight button
This increases the exposure by 1½ stops when backlight is pouring into the lens and deceiving the meter into underexposure. Mostly employed on auto compact cameras.

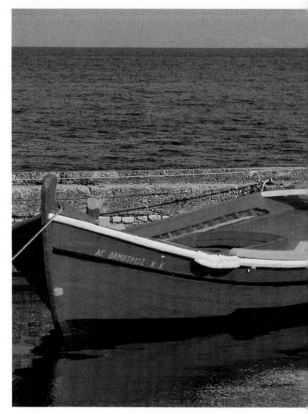

Correct exposure
This picture is an example of
what I would call correct
exposure. It is ¼ to ⅓ of a
stop darker than the film
manufacturer's ideal. The
darker exposure produces
stronger colour right through
the spectrum but the whites
are still clean. I uprate all
colour slide films to achieve
this: 64 ISO to 80; 100 ISO to
125; 400 to 500 etc.

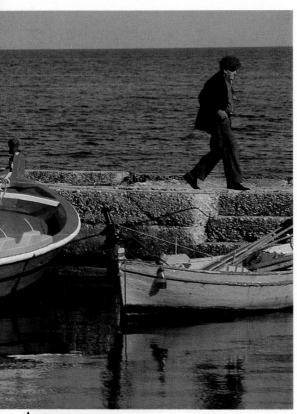

A

B

Backlight
Strong backlight results in exposure problems because the light pours straight into the lens, causing the meter to underexpose the subject as in frame **A**. Overexposure by 1½ to 2 stops corrects this problem as in **B**.

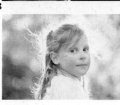

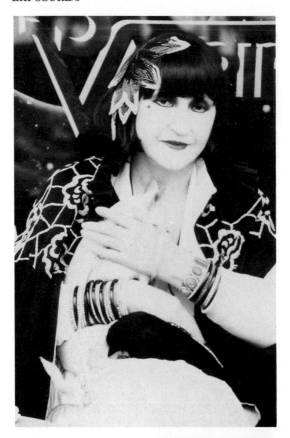

Mikado Lady
This picture represents an
example of overexposure for
effect. It was taken at the
Cannes film festival. The
lady was made up in a white,
almost Geisha makeup,
sitting in the famous terrace
café of the Carlton Hotel. I
deliberately overexposed the
picture by ⅔ stop. It's
impressionistic rather than
realistic.

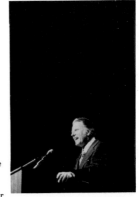

Billy Graham
The camera is trying to expose
for the dark background and
has overexposed the small
figure. A spot meter is ideal for
this situation.

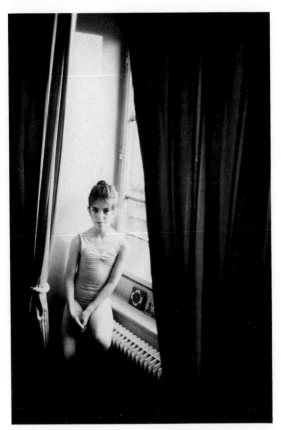

Window light
The camera is trying to make
a compromise between the
dark curtain and the
brightly-lit little girl,
resulting in the girl being
overexposed. Take reading
right off the face when using
window light.

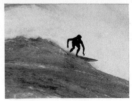

Surfer
The opposite exposure
problem for the auto camera.
The white foaming wave has
tricked the camera into
underexposing the surfer while
attempting to provide detail in
the wave. Take incident meter
reading, 18% grey tone (end-
papers) or meter your hand.

The exposure was made of the extreme highlights of the glass bowl (2½ stops under the general meter reading). The resulting photograph is much more dramatic than it really appeared to the eye. The underexposure of the landscape has emphasised the shape of the bowl.

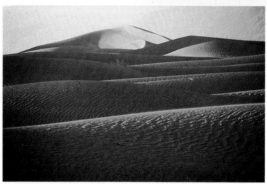

Death Valley
This is the camera's correct exposure and it is how the desert dunes really appeared. The camera exposed for the shadows.

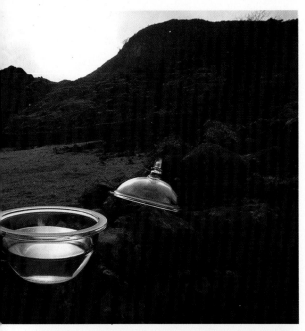

This exposure was made
1½–2 stops under the
camera's reading, resulting
in a more dramatic picture
by exposing for the
highlights.

LENSES

Manufacturers' brochures show us that lenses of different focal lengths have different angles of view. For example, a 15mm (wide-angle) lens takes in 110° and an 800mm (telephoto) lens takes in only 3°.

When selecting a lens you should take into account the properties of that lens for controlling perspective, and its inherent depth of field. The shorter the focal length (wider the angle) of a lens, the greater is its depth of field. Conversely, the longer the focal length the smaller is the depth of field. So don't just select a wide-angle lens to "get more in" or a telephoto to "get closer to", the subject. Use the creative possibilities that their depth of field and perspective control provide.

Photographers have their own favourite lenses, which complement their personal view of the world and design sense.

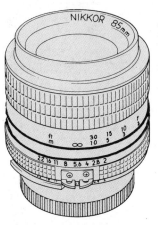

Each f-stop number is in a different colour. On each side of the white focusing line, there are pairs of lines matching the colours of the f-stops. Focus the camera and set the aperture. If the f-stop is f8 (pink in colour), find the distances opposite the pink depth of field lines. The measurement between the shortest distance and the longest distance is the depth of field of that particular lens focused at that distance and set at f8.
The red dot is the focusing position for the infra-red film.

Control of perspective is one of the major factors influencing our choice of lenses for any picture.

Wide-angle lenses exaggerate the distance between objects in the foreground and objects in the background of a photograph. Telephoto lenses compress the foreground and background, making them appear much closer together than they really are. A 50mm lens reproduces about the same perspective as the human eye and is therefore referred to as a "normal lens" in 35mm photography.

An example of how lenses alter perspective, changing the relationship of foreground to background.

300mm
The telephoto has compressed the perspective, bringing the monument much closer to the model than in reality.

105mm
The slightly long-focus lens has brought the monument closer to the model than the human eye.

24mm The wide angle has exaggerated the distance between the model and the monument.

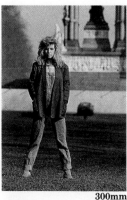

300mm

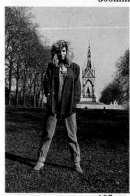

105mm

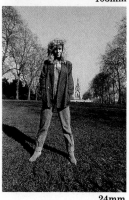

24mm

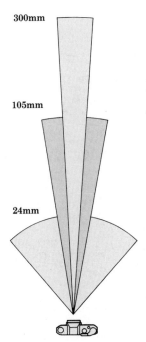

300mm

105mm

24mm

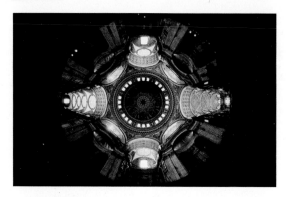

8mm
Fisheye view of the dome of St Paul's cathedral. Originally designed for a meteorologist to photograph cloud formations, the extreme distortions produced make this lens unsuitable for most subjects.

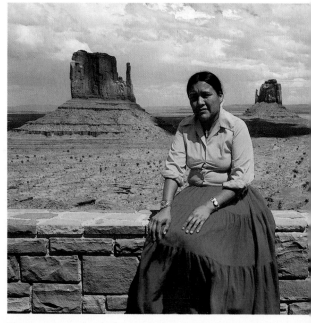

15mm
Mosque interior – an extremely wide angle has visually described a large area of the Blue Mosque in one picture.

24mm
A wide-angle lens used to make an environmental portrait, enabling us to see this Navajo Indian woman with her home lands (Monument Valley) behind her. Don't shoot any closer to the subject than this, otherwise distortion will be created.

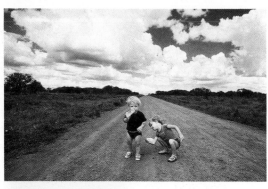

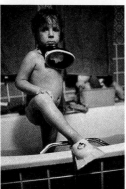

24mm
Classic perspective exaggeration of wide-angle lens. The clouds appear to be exploding out of the picture. The lens added drama to an ordinary picture. Red filter.

35mm
The slightly wide-angle effect of the 35mm lens has strengthened the line of the leg and emphasised the flipper in the foreground, thus making the picture more comical.

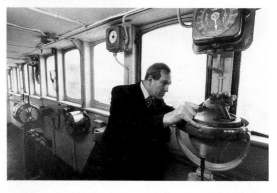

18mm
In the confined space of a ship's bridge the exaggerated perspective made the hands (close to the camera) appear larger than life. The parallel lines have converged to create a strong composition. Beware of getting too close to faces as this will result in distortion.

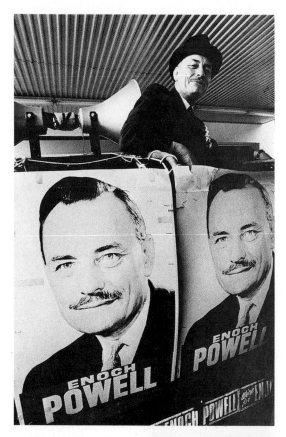

28mm
Campaigning right-wing
politician Enoch Powell. The
28mm view of perspective has
made a more dynamic
composition than would a
normal or long lens. A lens can
affect the journalistic
statement made by a
photographer.

50mm
The largest aperture lens in
the range, ideal for portraits in
low light conditions.

B

A

80–200 zoom
A range of lenses in one lens. These pictures demonstrate the zoom's ability to "pick off" different compositions, out of the one situation, within a short time span. Picture **A** on 80mm and **B** on 150mm. Don't be put off by anti-zoom traditionalists: the quality is now excellent. A great lens for child photography.

Teleconverter
A teleconverter (fitted between the camera body and the lens) has doubled the focal length of the 300mm lens up to 600mm. I lost 2 stops in exposure (f5.6 down to f11). Using a teleconverter is an economical way of making super telephoto pictures (a space saver for travellers). Quality of image not quite as good as using a primary lens but good for an effect. (Above right.)

Use a tripod – the longer the lens, the greater the risk of camera shake.

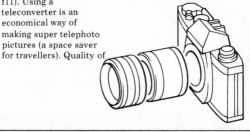

105mm
Often referred to as the "portrait lens" because it is possible to fill the frame with a face without distorting the features.

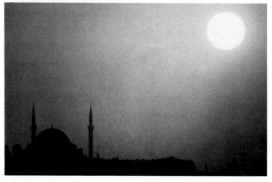

500mm (top)
The narrow angle of view of the 500mm mirror lens has excluded all background except for the water. Note the doughnut effect of the out-of-focus highlights on the water (typical of mirror lenses).

Mirror lens (reflex lens)
Super-telephoto lenses that use a combination of lenses and mirrors to bounce the optical path back and forth inside the barrel, thus producing an ultra-telephoto lens which is physically much shorter than a conventional one. The maximum aperture is smaller than in conventional lenses of equal length and is fixed (the diaphragm is not adjustable). Exposure can be varied by changing shutter speeds or by neutral density filters.

Lens flare
If you point the lens at or in the direction of the sun, you will get internal light reflections on the film, which appear as a "flare". Used intelligently, this can enhance the feeling of brilliant light. To avoid flare, shade the front of the lens with your hand, making sure you don't block out the lens.

300mm (left)
Istanbul sunset. The 300mm has "pulled the sun closer", making it appear much larger than normal. A 300mm is useful, as it gives real telephoto quality and is easy to use.

400mm (below)
The bull (old cow) appears to be very near the matador. The distance between them was in fact about 30m/98ft. The 400mm has compacted the perspective, giving a false impression of bravery.

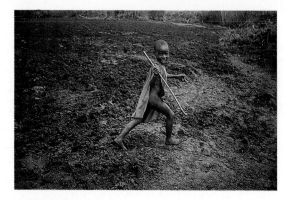

35–105 zoom
The normal range zoom is ideal for following focus and holding frame on moving subjects. Choose a lens that zooms and focuses in one movement.

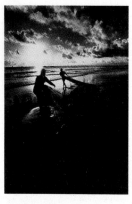

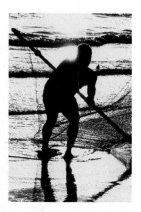

Kenyan fishermen
These two pictures were taken within a few minutes of each other. They demonstrate the dramatic change of composition and therefore the story-telling emphasis that two different lenses can have on the same subject. The picture left was shot on a 24mm wide angle, producing a gentle image of the fishermen putting out their nets at dawn. I then changed to an 80–200 zoom at 200mm. We have now a composition of horizontal lines cut by the diagonal of the pole (right). The silhouette of the fishermen is a powerful shape. This is no longer a pretty picture but a bold one. Consider carefully which lens you select.

400mm 300mm 200mm

● ● ●

· · ·
100mm 50mm 35mm

Photographing a sunset
Don't include the sun when metering for a sunset, otherwise underexposure may well be the result.

A setting sun looks enormous to the eye but it doesn't to the camera; the above chart shows what size the sun will be on a 35mm format, using different focal-length lenses.

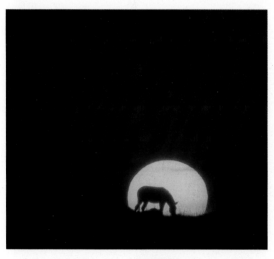

1000mm
The 1000mm has "pulled up" the sun so large that I was able to frame a zebra in its centre. You must use a solid tripod for such a long telephoto. I used a bean bag on the roof of a truck. 400 ISO film is required.

FLASH

The first question to ask is "does this picture need a flash?" A flash will kill the existing light quality. Maybe a fast film, a large aperture lens and a tripod will do a better job. The hand flash is not a last resort light, but rather an alternative and potentially exciting light source with unique characteristics. There are two flash systems on the market that have largely eliminated the problem of correct exposure: the TTL (through the lens) system and the computer sensor system – some units have

Nikon Speedlight SB-24
Dedicated to F4 and F801 cameras, this unit has TTL metering (auto), tilting and rotating head for bounce flash. The infra-red autofocus illuminator switches on when light is too low for focusing and autofocus camera can be focused even in the dark.

Ring flash
Electronic flash unit which fits round standard or macro lens, the circular flash produces soft, even light which is ideal for close-up pictures.

How to use a manual flash unit
1. Mount the flash on to the "hot shoe" on top of the camera.
2. Set the correct shutter speed: $^1/_{60}$ second for most automatic cameras. Set the film speed on the flash unit.
3. Switch on the flash unit, focus on the subject, take a note of the subject's distance on the distance scale on the lens.
4. Look on the back of the flash unit for the flash calculator scale, find the correct aperture and set that on the lens.
5. Take the picture when the red light on the flash unit glows.

both. The computer flash monitors the volume of light reaching the subject. You set the f-stop required (choice of 3 or 4) on the computer dial and the same f-stop on the lens. The TTL system measures the light that actually reaches the film through the lens. Set the aperture (any aperture, as long as you are not too far from the subject) and the flash will produce the correct amount of light for that aperture.

Camera manufacturers have introduced "dedicated" TTL flashes that work only on their own make of camera.

Vivitar and other manufacturers make TTL flashes with "dedicated" modules that match all the leading models.

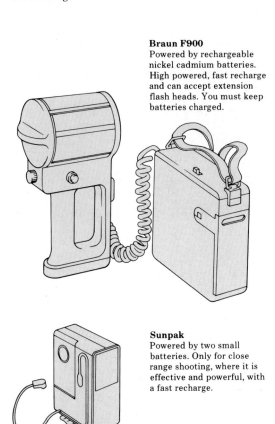

Braun F900
Powered by rechargeable nickel cadmium batteries. High powered, fast recharge and can accept extension flash heads. You must keep batteries charged.

Sunpak
Powered by two small batteries. Only for close range shooting, where it is effective and powerful, with a fast recharge.

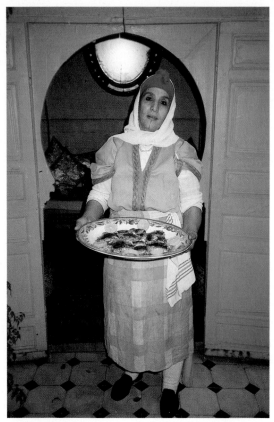

Bounce flash

Direct flash is a sharp, hard light source. By bouncing the light off a ceiling or a nearby wall, the light is spread and softened. For colour film, the bounced surfaces should be white, otherwise colour distortion will occur. A bounce off a white card or even a white shirt works well.

Girl in a white suit
(opposite)

A flash bounced off the white ceiling from the side. The light is soft and natural but sharp for the texture of the suit. Flash gun used: the powerful Braun F900.

Moroccan woman
Direct flash – compact camera (above).

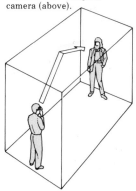

Finding the flash units guide number

For some specialist applications of flash such as fill-in flash, close-up flash, bounce flash, you need to know your flash units number. A quick and simple method is to set the film speed on the flash unit, look at the calculator dial and multiply any aperture by its corresponding distance (in feet): that is your guide number in feet for that film speed. For example, with the

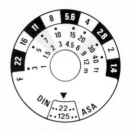

dial set at ISO (ASA) 125, f8 corresponds to 10 feet 8 × 10 = 80, which is your flash units guide number.

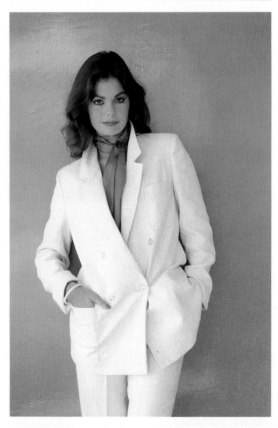

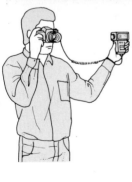

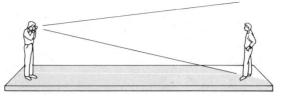

Hand flash

Use the flash on an extension cord, for there is a danger of the flash "missing" the subject when it is mounted on the camera while working close-up. Set the flash on auto, holding it at the minimum distance from the subject indicated by the autoflash calculator dial. For manual flash, use the tables to calculate the f-stop required. It is safest to bracket the exposures. Side light for texture, top light for shadowless light. Bounce the light off the white reflector for soft light (increases the exposure by 1 or 2 stops – still bracket). Don't forget direct flash decreases dramatically with distance.

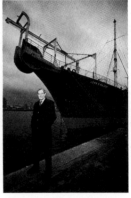

Painting with light
(opposite)

The picture opposite bottom was taken with the available light. In order to bring detail to the dark areas, the picture opposite top was taken with the shutter open (on time or on B with a cable release).

The aperture was set at f8. The dark areas were lit by firing a hand flash using the button on the flash. This painting with light technique is often used on churches. Vary the number of flashes depending on the atmosphere you wish to create.

Man and ship (above)

In the shot above left no flash has been used; the light was flat and lacked drama. Exposure 1/60th sec at f8. In the shot above the camera was set at 1/125th sec at f8. The autoflash was set for f8. The balance of light in the picture has been altered, the background is now relatively dark. The picture on the right is more dramatic than the picture on the left.

Tungsten flash
Tungsten light (top) plus
daylight at the back of the
room. Exposure ½ sec at f8.
Bottom picture: autoflash at
f5.6 and lens at f8.
Exposure was f8 at ½ sec.

Opposite
Top left
Flash at arm's length above
camera.
Top right
Flash at arm's length on 45°
from camera.
Centre left
Flash side lit.
Centre right
Flash same position as in
picture left, model turned
profile towards the light.
Bottom left
Flash from near floor height.
Bottom right
Flash set up behind head,
facing head and camera. A
white reflector held above
camera to direct the light
back onto the face.

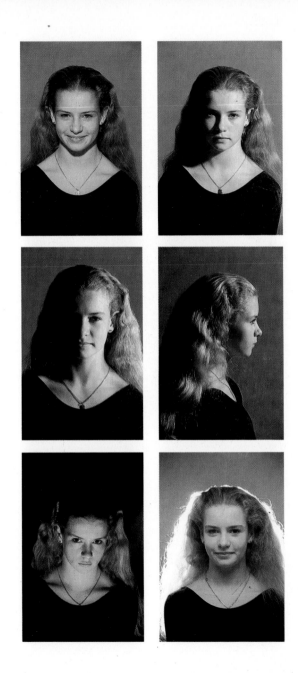

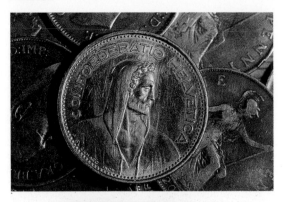

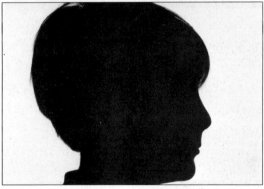

Coins
Shot on a 105mm macro lens.
I experimented with the
angle of the flash on an
extension. I used the close-
up tables as a guide to
expose, then bracket. This
picture was taken at f8. I
used a white reflector
opposite the low angle flash
to fill in. The low angle light
has accentuated the relief of
the coin. The other method
for close-up flash is ring
flash. The ring flash makes a
shadowless, and therefore
very descriptive, light with a
dark edge on the subject.
This shot was taken on auto
with a dedicated ring flash.

Silhouette
A flash gun hidden behind
the subject's head and
directed onto the white
background has produced a
modern version of Victorian
silhouette. Experiment with
exposure.

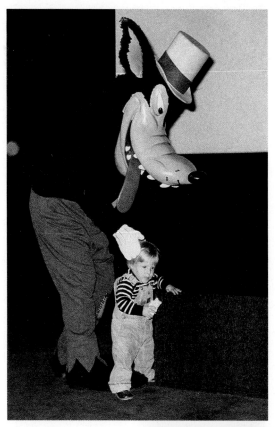

Big bad wolf
This picture of my son Matt
and the big bad wolf has
caught the action. The hard
flash works well on many
action pictures when you
want to freeze a moment and
when there is little light. Set
on TTL Auto.

Albert Finney
Using direct flash from low
angle for more drama, I
filtered the flash with an 81C
gelatine filter (made by
Kodak), which warmed the
normally cold flash light, and
used a diffuser like Vivitar's
own brand.

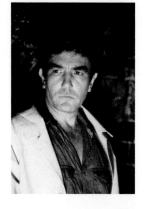

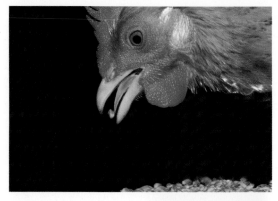

Hen
The hand flash has frozen a piece of wheat on the tongue, allowing us to make an observation impossible to the naked eye. Shot with a computer flash set on f16 and held 15cm/6in to the left of the camera. Flash filtered with 81A + 5R gelatine filters.

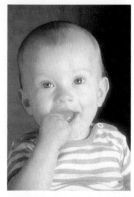

Nathan
Lit with one computer flash diffused with tracing paper at approx 45° between the camera and the baby. There is a large white reflector next to the baby on the left hand side to fill in the shadow. Flash and camera set to f8.

English woman
The fill-in flash was bounced off a white reflector. The flash was filtered with an 81D filter. Most of the latest autoflashes will calculate fill-in flash automatically.

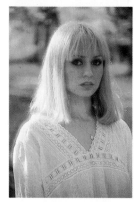

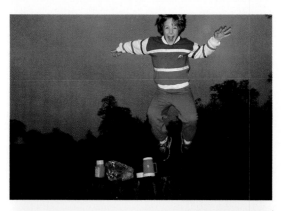

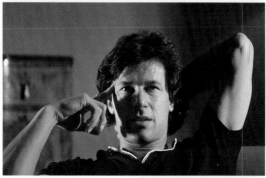

Matt jumping
The exposure reading by the
camera for the sky and the
trees was f8 at 1/60th sec.
I set the camera at f8 at
1/250th sec (Nikon FE2
synchronises at 1/250th) to
underexposure the background
by two stops. The computer
flash was set at f8.

Imran Khan
This multiple flash was shot
on manual setting. I set the
exposure on the calculator
dial for the main light
(coming from the right) and
then placed the second light
on the left at the same
distance from Imran Khan. It
was fired by a small slave
unit from the light of the
main light synchronised to
camera.

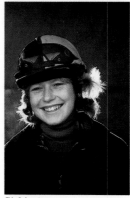

Girl jockey
Girl's hair was backlit from a
window but the face was very
dark. Fill-in flash was the
answer.

LIGHTING

There are two forms of artificial studio lighting: traditional tungsten lighting and electronic flash.

Tungsten lights are balanced to work with artificial-light film, but an 80A filter (blue) is required to balance daylight film. Recent developments in quartz light bulbs by cinema lighting technicians have produced relatively small lights with a high output and which emit less heat than tungsten lamps.

Electronic flash is powered by normal domestic electricity and is balanced to work with daylight film (5400–5600 Kelvin). Most professionals use it because the short duration of 1/400th to 1/1000th sec assures them of sharp pictures with correct colour balance. The power of electronic flash units is measured in joules or watt seconds.

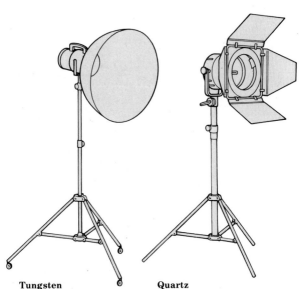

Tungsten
Photoflood tungsten lights come in an almost infinite variety, from huge 10k floods "brutes", to tiny point source spots "inky dinkies". Many photographers have changed back to tungsten lights for the great control they offer.

Quartz
Evolved by the cine photographer. They are compact and produce little heat. The Lowel Omni light system is extremely useful for 35mm work, providing a whole studio in a suitcase.

Snoots and reflectors

A reflector is a metal shield that fits on a light and directs the beam. There are many shapes and sizes of spotlight accessories, including barn doors and snoots which restrict the light. Filter holders add to the range of effects that can be achieved.

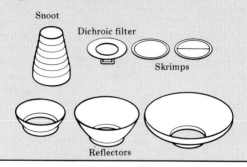

Snoot

Dichroic filter

Skrimps

Reflectors

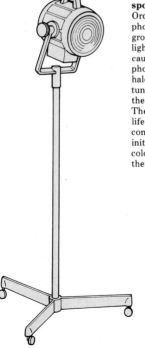

Tungsten-halogen spotlight

Ordinary bulbs, both photographic and domestic, grow dimmer with age; the light also becomes redder, causing problems with colour photography. Tungsten halogen bulbs stay clean and tungsten is redeposited on the element upon cooling. These bulbs have a longer life and colour output stays constant. They cost more initially but long life and colour consistency makes them a good buy.

Lighting checklist
Do not use a powerful light bulb in a household light fitting for more than 10 minutes – it will melt.

Do not overload power supplies – lights use a great deal of power.

Do not shine lights directly into your subjects' eyes.

Do let your lights cool before moving them – they will last longer.

Do not move lights without switching them off.

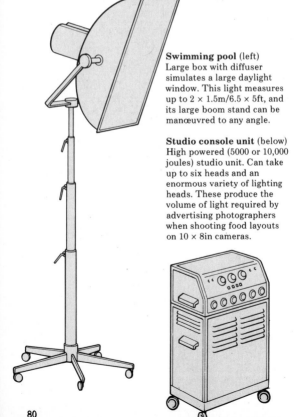

Swimming pool (left)
Large box with diffuser simulates a large daylight window. This light measures up to 2 × 1.5m/6.5 × 5ft, and its large boom stand can be manœuvred to any angle.

Studio console unit (below)
High powered (5000 or 10,000 joules) studio unit. Can take up to six heads and an enormous variety of lighting heads. These produce the volume of light required by advertising photographers when shooting food layouts on 10 × 8in cameras.

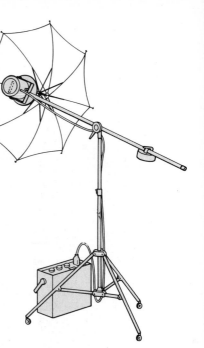

Brolly

Umbrellas in white, silver and gold are often fitted to electronic flashes. The flash bounces into the brolly, reflecting out as a much broader and softer light. Golden brolly for warm skin tones.

Bowens Quad 2000 (above)
It produces 2000 joules of light. Up to four heads can be run from one pack; controls are on the pack – except modelling light dimmer switch on head. Several packs can be linked together into one powerful head.

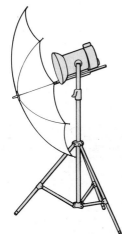

Bowens Monolite 400 (left)
The power pack is built into the head. A tungsten modelling light acts as a guide to the picture to be taken by flash. Can be set to 400, 300, 200 or 100 joules. Ideal for location work as any number of heads can be synchronised by plugging in slave units. They produce enough power for 35mm or 6 × 6cm work but not sufficient for 5 × 4in or 10 × 8in cameras. Similar units are made by Elincron and Metz.

81

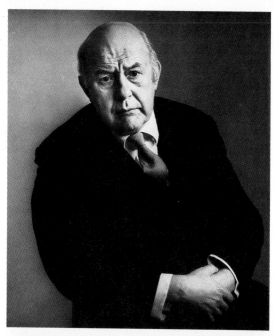

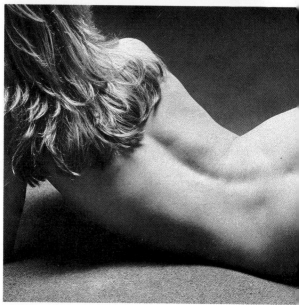

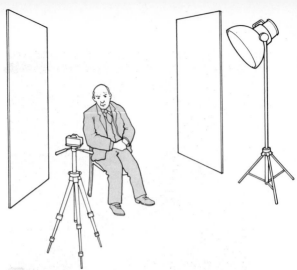

The portrait of Sir John Betjeman was lit with a simple, large umbrella set high and to the right of the camera. The light was shaded off the right-hand side of the grey background by a translucent blind so as to hold a dark area behind the brightly lit side of the face. A white reflector was positioned opposite the light to reflect some detail back into Sir John's face. When shooting black and white portraits, use your lighting to achieve a light tone against a dark and vice versa.

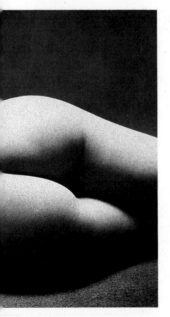

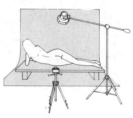

Nude back view
The soft top light has emphasised the round shapes and form of the nude. A front light has the effect of flattening the round shapes and reduces the appearance of form and volume. You must also light and illuminate the good features of the body and throw the worst features into shadow.

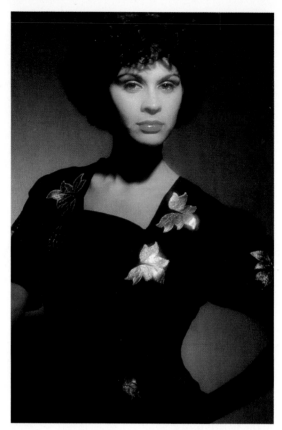

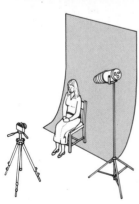

Girl in black dress
The high single spotlight has narrowed the jaw line and emphasised the model's high cheek bones. Only the face and the gold embroidery have been picked out by the spot. A number 1 Softar filter on the lens has softened the effect of the spot which can be harsh.

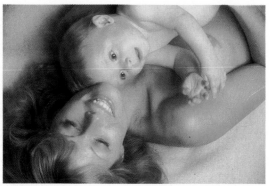

Mother and baby
Shot from the balcony of my studio with mother and baby lying on a matress. The lighting is high, broad and softened by draping tracing paper over the umbrellas. I have reproduced my studio daylight effect because the baby was moving too fast for me to keep him sharp using daylight.

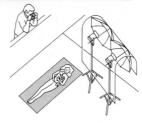

Mother and baby (below)
The main light comes from a single umbrella next to the camera. The two backlights are ensuring a clean white background.

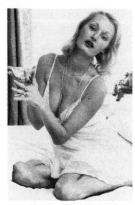

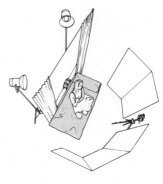

Two lights were set up outside the bedroom window and directed back at the white reflectors around the camera. There is no direct light hitting the model – it is all bounced off by the reflectors, producing what is called high-key lighting (shadowless).

A single high spot, combined with a generous exposure (+½ stop), has resulted in a sophisticated image. It would be less effective if the face were not surrounded by black.

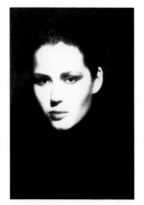

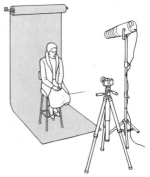

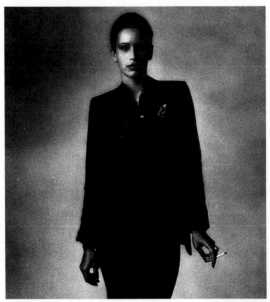

A simple side light using a black blind opposite the light so as to hold a strong black in the shadow side and in the suit.

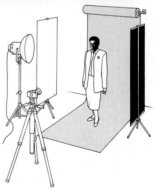

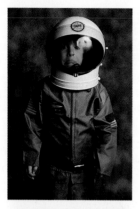

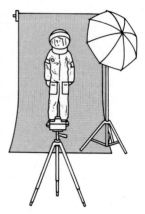

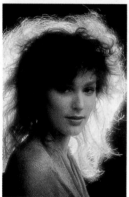

Spaceman (above left)
The grey background was sprayed with white pressure-pack paint for a cloud effect. The high umbrella has reflected in the visor of Buck Rogers' space helmet, adding to the 'spacey' atmosphere.

Backlit hair (left)
The backlight was directed through a hole cut in the background paper, producing the halo effect. This set-up can only be used for stationary subjects. Be careful to take the exposure reading with the backlight turned off, otherwise it may pour directly into the meter, causing underexposure. Vary the relative power of your front and backlight, depending on the effect you require.

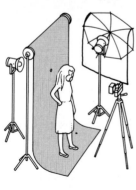

Kiwi fruit (opposite top)
The slices of Kiwi fruit were placed on a transparency-receiving light box (corrected for daylight film). The highlights were provided by a low-powered top light. Try window light as the top fill-in light also.

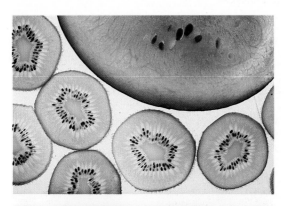

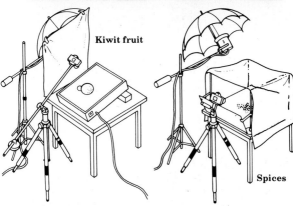

Kiwit fruit

Spices

Spices (above)
The classic commercial still-life lighting set-up. A high soft light slightly backlighting the subject with a reflector in front to fill the shadows. Considerable variation can be obtained by varying the position of the top light.

Available light photography

Low level artificial room light requires fast film and large aperture lenses (your 50mm). This type of photography is referred to as available light photography. If you can see it – shoot it!

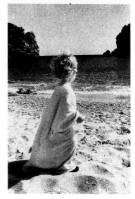

Back light

The early morning has provided a back light that has given the baby's hair an angelic glow. The white sand has made a natural reflector, filling in the shadows.

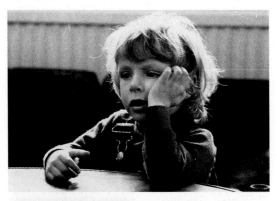

Backlight from window
When the window is above
and behind the subject, a
halo light is acheved.
Exposure readings should be
taken off the face.

Dull overcast
Cold, damp, overcast –
doesn't sound or look
promising, but if the content
is good, don't put away the
camera. There is almost no
bad light for photography.

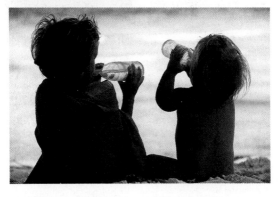

Silhouette
The end of a hot day at the
beach. Expose for the
background (the figures are
therefore 1½ stops
underexposed).

Dawn light
The blue and pink dawn light
is the sharpest light of the
day, unless the landscape is
shrouded in mist.

Late morning light
You can use the strong late
morning light straight on as a
spotlight or as a cross light
on textured surfaces.

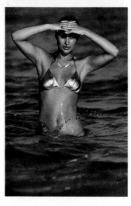

Midday light
Kenya – almost on the
Equator with the sun
overhead. A difficult light for
portraits because the face is
in shadow, but good for a
hard-edged graphic
definition. Expose for the
highlights and let the
shadows go black.

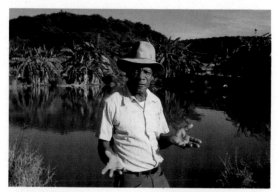

Late afternoon
Two hours before sunset the light is warm and rich in colour. Good light for most subjects.

Sunset – pylons
Try to find a frame for the setting sun to identify the location and make the composition more interesting.

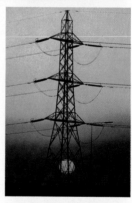

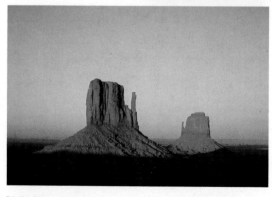

Light from sunset
The warm light from the sunset is a dazzling light source when used as a front light. Almost any subject looks better than it did earlier in the day.

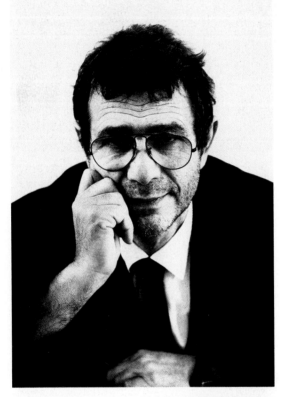

Man with glasses
Reflection can present
problems when lighting
people wearing glasses. This
portrait was lit from each
side to avoid reflections of
the lights appearing in the
glasses.

Boy cricketer
Portrait made in a daylight
studio. The windows should
face north so that the light is
never direct and always
reflected off the sky.

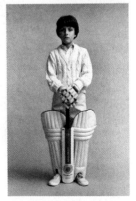

Bonfire
One of those occasions to resist reaching for the flashgun because it is night-time. There is often more light (and interesting light) than first seems apparent. Take close-up readings.

Fireworks
For 100 ISO film set aperture at f11 and leave the shutter open. Cover the lens with your hand and then remove to expose a burst of fireworks. You can repeat several exposures on the same frame.

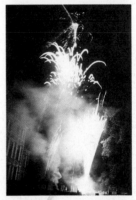

TV screens
Must shoot at 1/8th sec or slower for SLR cameras and 1/30th sec or slower on others. Set shutter speed and then adjust aperture till you can obtain correct exposure. Use a KR6 or a CC40R filter.

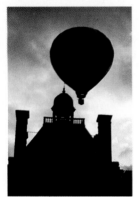

Silhouette balloon
Early morning and late afternoon light provides opportunities for silhouettes against the sky. Try to reduce objects just to positive shapes (blacks) against the negative shapes (light tones). Underexpose by 1½ to 2 stops.

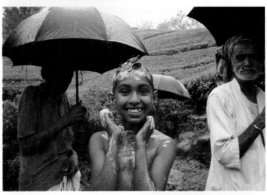

Rain
Don't pack the camera away when it starts to rain. It is one of the best conditions for interesting photography.

Special twilight
When the sun sets, it is not the end of the photographer's day. The twilight is soft and magical. Use a tripod and try long exposures just before nightfall.

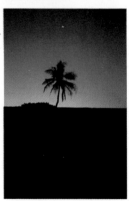

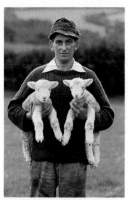

Lambs
A miserable-looking day (exposure reading only 1/60th sec at f2.8 on 400 ISO film) but with the help of an 81C filter, providing a good soft portrait light.

Stormy clouds
Keep camera ready on stormy days for when the sun breaks through, even if only for a few moments. The light has a glowing quality.

Window: girl with melon
Window light used as a side light. Variations can be made by using reflectors to fill in the shadows. Close-up meter readings.

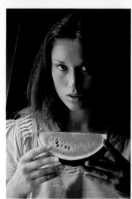

Coloured filters are used in black and white photography to increase the contrast between tones of grey. Filters lighten the tonal reproduction of colours in their own end of the spectrum and darken those at the other end.

A yellow filter will hold the tone in a blue sky, while giving separation from the clouds; an orange filter will darken the sky.

Care should be taken with exposure – expose for the shadows, otherwise the filter will increase the contrast in the negative.

Smooth white skins in portraiture are acheived with red filters.

Subject	Effect	Suggested filter	Exposure increase
	Natural	No. 8 Yellow	1
	Darkened	No. 15 Deep Yellow	1⅓
		No. 21 Orange	2⅓
Blue sky		Polarising filter	1⅓
	Greatly darkened	No. 25 Red	3
	Almost black	No. 29 Deep Red	4
	Water dark	No. 15 Deep Yellow	1⅓
Marine scenes with blue sky	Natural	None or No. 8 Yellow	1
	Increased contrast	No. 15 Deep Yellow	1⅓
		No. 25 Red	3
	Increased haze effect	No. 47 Blue	2⅔
Distant landscapes	Haze reduction	No. 15 Deep Yellow	1⅓
		No. 21 Orange	2
		Polarising filter	1⅓
	Greater haze reduction	No. 25 Red	3
		No. 29 Deep Red	4
Outdoor portraits against sky	Natural	No. 11 Yellowish-Green	2
		No. 8 Yellow	1
		Polarising filter	1⅓

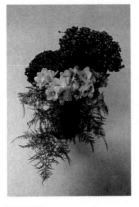

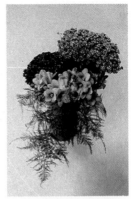

B&W filters
This is a B&W shot (above) of the flower arrangement on page 100, without a filter. Note the tonal values of each colour.

Blue filter (above right)
A blue filter has lightened the blue flowers and darkened the red and yellow flowers.

Red filter (right)
A red filter has lightened the red and yellow flowers and darkened the blue flowers.

See page 100 for colour reference.

The Cokin creative filter system (right) is attached to the lens by an adaptor ring and takes round or square filters, modular lens hoods and a filter holder which will take up to five filters.

Warming filters intensify most colours except blues. They are very effective on skin tones, and for lifting the colours on dull overcast days. The best known range of warming filters are the 81s ranging from 81A to 81EF. Polarising filters are essential for the serious photographer; they hold colour saturation in directly lit subjects and control the effects of reflective surfaces such as glass and water. Polarising filters will bring out the blue sky and clouds, which red filters do on B&W film.

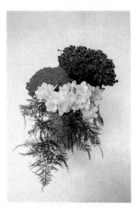

A good understanding of filtration in colour photography enables a photographer really to take control of the colour of his pictures. Combined with sound knowledge of film types, light sources and lensing, a modern photographer can be almost like a painter mixing his paints on a pallette. The potential for controlling colour is considerable.

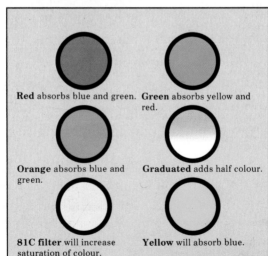

Red absorbs blue and green.

Green absorbs yellow and red.

Orange absorbs blue and green.

Graduated adds half colour.

81C filter will increase saturation of colour.

Yellow will absorb blue.

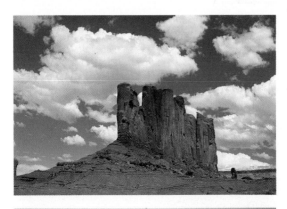

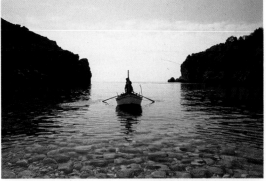

Monument Valley
Traditional polarising filter
shot: the blues have gone
.darker and the clouds appear
whiter. Be careful not to
make the sky black by
dialling in too much
polarisation, beware of a
tendency toward
overexposure with polarised
landscapes.

Boat
The polariser has cut the
reflection on the water and
enabled us to see through to
the pebbles (will work in any
light conditions).

Yellow and blue truck
The polariser has increased
the contrast between the
colours. Use for "hard
edged", abstract colour
pictures.

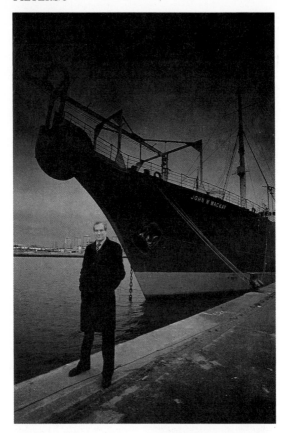

Graduated filters

Graduated filters (grads) are half clear and half colour or tone of grey (neutral density grad). They can be a round, screw-in type that rotates to any position, or an oblong shape that can be moved up and down or rotated in a holder to the required position. Grads are used when the exposure range of the subject is too great for the film to handle or when you choose to add colour or tone to an area of the picture. Beware, don't stop down more than 2 stops on wide angle lenses or the line will show between colour and clear.

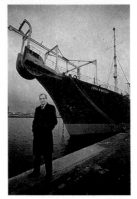

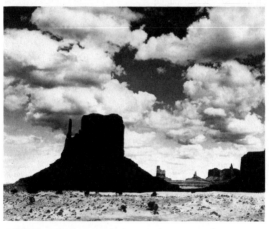

Graduated (opposite top)
The graduated filter has made the top half of the picture darker and more dramatic, without altering the tones on the bottom half. A red filter wouldn't have darkened the sky because it was only grey cloud (no blue to darken).

The bottom picture was taken without a filter.

Red filter (above)
The dark red (Wratton 29) filter has lightened the foreground yellow sand and darkened the blue sky, accentuating the cloud formation. The increased contrast has left no detail in the shadowed monoliths of Monument Valley.

Pub
The exposure range between
the pub and the sky was too
great for the sky to register
its true density. The pink
graduated filter has "built-
in" a sky and a pink sunset
for good measure.

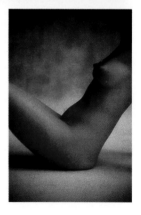

Nude
The 81EF filter has provided
the model with an instant
suntan. A soft focus filter has
combined to smooth the skin
tones.

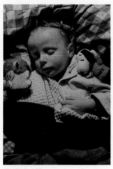
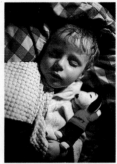

Baby asleep
Picture taken on daylight film in tungsten light – orange effect. An 80A

filter has corrected the colour; an 82C would give a colour balance half way between the two.

Type of Colour Film	Daylight	Tungsten	Photolamp
Daylight	No filter	No. 80A +2 stops	No. 80B +1⅔ stops
Tungsten	No. 85B +⅔ stop	No filter	No. 81A +⅓ stop
Photolamp	No. 85 +⅓ stop	No. 82A +⅓ stop	No filter

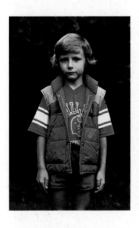
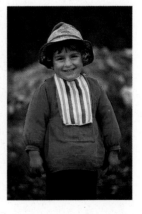

The picture of Nicholas was taken on a grey day in London without a filter – the skin tones are grey and lifeless.

I photographed this little chap on a grey, overcast day in Corfu. The KR3 filter has done its bit of magic – the skin tones are wonderful.

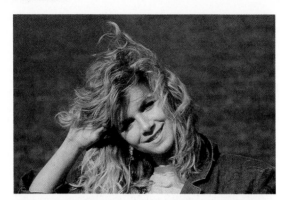

Home-made soft edge (above)
The soft filter (above) was made by applying some vaseline around the edge of an A1 (almost colourless) filter, leaving the centre clean. The soft focus filter has given a glow to the backlight and the skin tones.

Red filter (opposite centre)
The red filter has darkened the green grass and lightened the face. An orange or red filter is very effective for clearing spotty complexions in portraiture. No red filter was used in the picture opposite top.

Split image (opposite bottom)
Home-made split image effect created by holding a cut glass bauble in front of the lens.

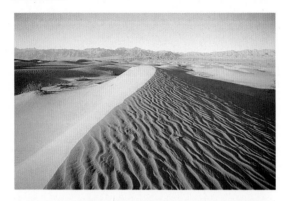

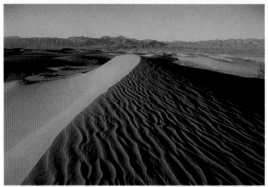

Desert
The desert was not as "sandy" looking as I had imagined (top). The A12 (the strongest of the 81 series) has made it appear as my "mind's eye" had seen it.

Tulips
KR3 has added life to the red tulips, and will also remove a green cast from skin tones when making portraits in the shade of a tree.

Light-balancing filters

To retain conventional colour balance at different times of day, particularly when using slide film, try using the chart below.

Daylight Source	Filter	Exposure Increase
Sunrise, sunset	80B	1⅔
	80C	1
2 hours after sunrise	80D	⅓
Overcast sky, Open shade	81D or 81C	⅓

Verona
The ancient city of Verona was looking drab in the cold, grey morning light. An 81D filter plus a neutral density grad have done the trick to make the city look more inviting (below right).

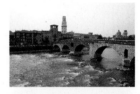

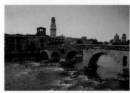

Snow
An unfiltered snow shot (right). An A2 filter has absorbed the blue from the snow and left it white. A KR3 or an 81A or 81B would do the job equally well.

COMPOSITION

Framing

Many of us see subjects that would make great pictures. But the great photographs are taken by those people who can arrange these subjects inside the frame to make a strong composition or design of shapes, colours or tones. Try to see subjects just as coloured shapes, animate and inanimate. A beautiful horse is a lovely creature but it is also a moving shape that can look pleasing or ugly depending on its position in relation to the background when the shutter is pressed. Be conscious of the spaces between and around the main subjects (the negative shapes). They are as important as the shape of the subjects themselves (the positive shapes).

Learn to search in the viewfinder to eliminate obvious eyesores, such as a pole growing out of somebody's head or old beer cans littering the ground.

Modern cameras have a built in compositional trap that we must be aware of. Because the fine focusing circle and the centre-weighted metering are all in the centre of the viewfinder, the photographer can be seduced into composing with the main subject bang in the centre of the frame every time – boring, boring!

Finally I believe that most photographic composition should flow logically from the need to tell a story in the most effective graphic way possible.

Policemen
The emotional impact of the photograph comes out of the composition. The figure about to be dragged into the great mass of policemen looks threatened. I saw the action from ground level and ran up into a high position to take this shot. Look for the high descriptive angle on action.
The decisive moment when you push the button will come with practice.

Composition checklist
Be prepared – the first frame may be the best.
Become thoroughly familiar with your camera and lens.
Don't leave the subject too small in the frame, be bold and fill the frame.
Search the frame to eliminate the ugly; look for other camera angle possibilities.
Don't carry more equipment than is comfortable.
Don't be tense and worried about your pictures.

Brush (top)
There are millions of patterns around us – learn to isolate them. Look at life just as shapes and colour and everything will start to fall into place. The colour harmony of pink and brown has been used here.

Peppers (above)
Contrasting colours can be effective. The peppers nearly jumped off the old blue-grey trays and demanded to be photographed. The red netting bag leads the eye to them. A 24mm lens (wide angle) allowed me to give plenty of grey colour around the peppers and so look into the trays from a close position.

Spaghetti (opposite)
Still-life allows you to create
your own compositional
patterns. The pasta was laid
on a light box. The strong
diagonals have made 4
triangles. Three with
different coloured pasta and
the fourth with the three
colours mixed. It is a good
idea to start by basing your
designs on geometric
patterns.

Apple (above)
A deliberate choice of
complementary colours (red
and green) for the
background – both of which
are repeated in the apple – is
a dynamic approach. The
round shape sitting on the V-
shape is simple but strong. If
the apple had been placed in
the centre of the frame, the
composition would have been
boring.

Masai women
I shot this picture at low angle, after first shooting several frames from eye level. I felt that the low angle was in keeping with the women's dignified, sculptured presence. A red filter was used.

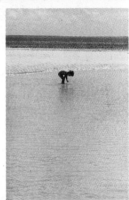

Boy on beach
The focal point of the little boy has been placed in the top third of the picture. It is the scale of the tiny boy in the great space that is most effective.

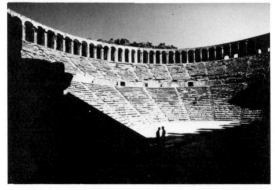

Focal point
The light and shade on the Roman amphitheatre in Turkey is quite dramatic but I needed a focal point. I asked two passing tourists to stand in silhouette for me. The two tiny shapes improve the composition considerably.

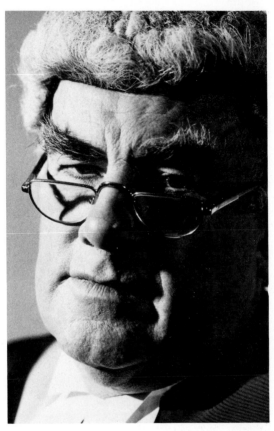

Judge Pickles
The controversial Judge
Pickles. I framed in very
tight on his head to
emphasise his tough,
uncompromising career. The
close-up of his face says it all
– nothing else is needed.

COMPOSITION/4

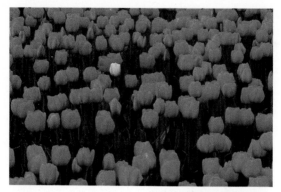

Tulips
Train the eye to isolate the
one detail. The one yellow
tulip in the field of red tylips
is just one example. A long
lens – 300mm plus 1.4
teleconverter – has
compacted the tulips closer
together. Grainy film was
used for its artistic effect
(3Ms 1000 rated 2000 ISO).
Notice that the yellow tulip
is not in the centre of the
frame.

Baskets of limes aren't just
baskets of limes – they also
form a semi-circular pattern
of green and yellow shapes.

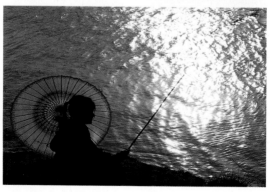

Girl fishing (opposite)
This picture was contrived.
The "fisher girl" was
carefully placed in profile
inside the round Japanese
brolly. A long lens (300mm)
has "pulled the water up" to
form a background.
Underexposure by 1 stop has
silhouetted the little girl.
The texture of the water
(backlights) is important to
the picture, but placing the
subject in the bottom left
hand corner has "made" the
picture.

Yellow dress – Green wall
I searched for this peeling
green wall to use as a
background for the girl in the
yellow dress. The texture
and faded colour offset the
smooth flow of the girl's
dress. Her shape appears as
a yellow triangle in a green
rectangle.

117

Olga Korbut's action appears more powerful because of the two strong lines of the parallel bars high above her in the darkness. If the supports to the bars were visible, the picture wouldn't have as much tension. In composition, what you omit can be more important than what you put in.

Old men: Greece
The pole and its shadow have divided this picture in two, emphasising the two old men's isolation in the same world. Each man is an "island".

The rule of thirds

Draw a rectangle representing the picture space and in it rule lines showing the thirds horizontally and vertically so that it is divided into nine equal parts.

Any one of the four points where the lines intersect is the strongest point in the picture and the best position for the most important feature. A good picture balances about its centre.

The dogs of St Tropez
The tension in this picture is created by the negative space between the dogs. The strong diagonal of the gutter zooms the eye from right to left.

119

Matt swimming (above)
The little boy learning to
swim was framed in the top
third of the picture: he
needed space to swim into
and there was more drama if
the water seemed deep.

Tree fairy (right)
Scale has been used here
again. The eye comes down
the huge tree to find the
little tree fairy locked in the
V-shape, emphasising her
petite femininity. The tree
forms a frame within a frame.

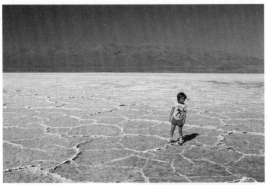

Salt flats (above)
A sense of scale can be important in landscape compositions. This picture would have no focal point and sense of scale without the little boy. The hot colours zing out of the neutral colour of the salt flats.

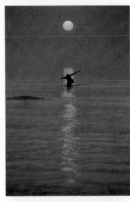

Sunset fisherman (right)
I saw the sunset and then the fisherman and kept walking up the beach until I could put both together. The fisherman is that final focal point that makes a sunset into a photograph. The sunset trail leads the eye up to the fisherman and the sun.

Red flowers, green blinds
The red tulip (right) looks vibrant against the green blinds. Both objects are at the opposite ends of the chromatic scale; which has a jarring effect on the eyes. Remember, it isn't always necessary to harmonise colours: occasionally use colour to shock. Use vibrant colour to emphasise a detail which could be lost in the general composition.

Man with finger in eye
A picture within a picture.
It's a feeling of uncertainty
that the image in the mirror
gives us. Which is the real
clown?

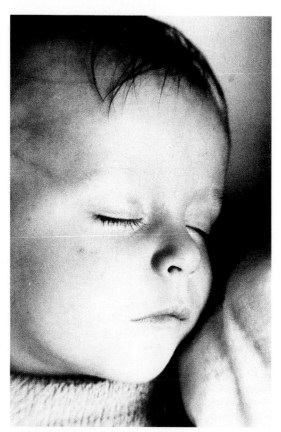

Nick asleep
The impact of this picture
comes from its bold framing.
It is softened by the touch of
the blanket next to the
baby's face which almost
repeats the outline of the
face.

Landscape: Kenya
The grass in the foreground
leads the eye through the
picture to the mountains and
clouds. Landscapes in
particular need a foreground
that leads the eye to the
point where you want it to
go.

123

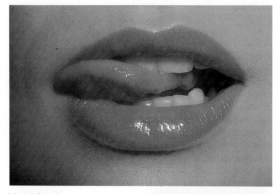

Lips (above)
We know that here is a beautiful girl from this close-up. The light shining on the lip gloss and tongue makes a texture that adds sensuality to the picture. Don't be shy. Get in close!

Worry beads (right)
Sometimes a detail can say as much as a whole street scene. Keep it simple. The black background of the man's jacket has helped the picture greatly. An 80–200mm zoom has enabled me to frame precisely from my table next door.

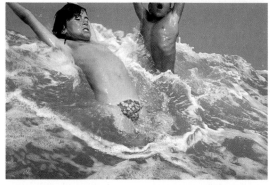

The swimmers appear to be almost washed out of the top of the frame by the wave. If I had framed them in the middle, the picture would have been less dynamic. (Shot on a Nikonos underwater camera.)

The two most important considerations for architectural photography are the camera angle and the quality of light falling on the building. The personality of a building is greatly enhanced by sympathetic light. The more knowledge you have of the building – the age, the materials used, the function, the history – the better will be your picture. Try to climb inside the architect's head and see the building the way he imagined it would look.

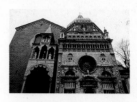

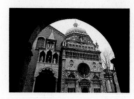

Monastery
The day I visited this monastery was dull and overcast (top). I masked out the grey sky with the arch and used an 81C filter to warm the colour.

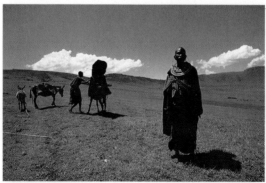

Masai women
The use of a dominant foreground figure with smaller figures in the background, is a classic compositional technique. I adopted a low camera angle to emphasise the woman's head against the sky; a polarising filter was used.

125

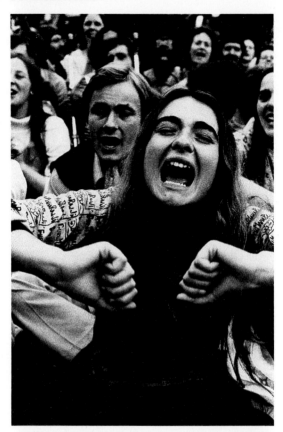

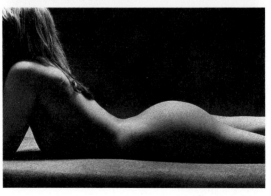

Portrait of a child (above)
This shot was taken in studio
daylight, on a Hasselblad,
using HP5 film.

Girl screaming (opposite
top)
The close-in framing on the
wide-angle (24mm) lens has
slightly elongated the girl's
face, exaggerating her
scream. The lens has placed
greater emphasis on her
hands that appear to be
trying to pull out the frame
of the picture, as if she were
trying to escape the
mundane world.
 Compose your picture and
wait for that moment when
the button must be pushed.

Nude (opposite bottom)
The curves of the nude are
emphasised against the
straight lines of the bed and
by the tonal separation of
dark to light to dark to light,
finishing on dark. It is the
tonal separation that gives a
feeling of form and volume to
B&W photography.

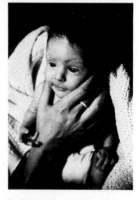

Baby and hand (above)
A sense of scale is important.
Here the mother's hand in
relationship to the baby's
face reminds us of the
smallness and vulnerability
of a newborn baby.

127

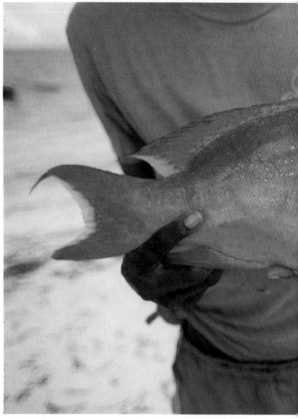

Fish (above)
I couldn't resist making a
picture when I noted the
colour of the fish and the
fisherman's shirt. The shot
needed nothing else. A wide-
angle lens (24mm)
exaggerated the size of the
fish effectively.

Flower (opposite)
Another light box set-up.
The blue and pink
background is made with
Japanese tissue paper. The
tulip is coming into the
picture from the top left
corner, giving a feeling of
movement in a still life. The
pink tissue balances with the
pink in the tulip. The
harmonised colour is very
gentle and feminine.

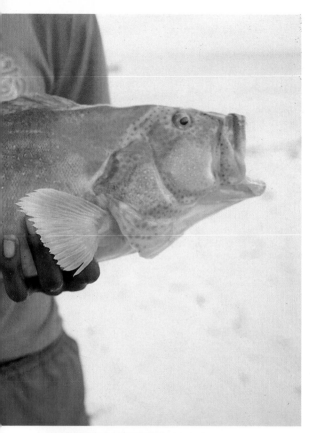

PHOTOGRAPHING PEOPLE

The biggest obstacle we have to overcome before taking good portraits is our own shyness – the natural reticence we all feel when asking someone to pose for us. Confidence in your own technique will help – work on it, so that you don't become flustered in front of the sitter and lose the subject's confidence. A person has five senses that all relate to make up a personality (or perhaps even a sixth sense). Photographers have only the physical, the external evidence, to work with to represent this personality on film.

Observe the hand movements, the carriage of the head, the shrug of shoulders, the shy smile or the eyes that light up with amusement. The lines on the face of an old man are no accident of chance – they are the result of the life he has lived and are a map of his life.

The great portrait relies on the split second when the photographer pushes the shutter – to capture on film the essence of the subject's personality.

Vary the lighting or camera angles to get the best picture of your subject – follow the chart below.

Prominent forehead	Tilt chin upward Lower camera position
Long nose	Tilt chin upward Face directly toward lens
Narrow chin	Tilt chin upward
Baldness	Lower camera position Blend top of head with background
Broad face	Raise camera position Turn face to three-quarter view
Wrinkled face	Use diffused lighting Use three-quarter pose
Double chin	Tilt chin upward Use high camera position
Prominent ears	Turn head to hide far ear Keep near ear in shadow

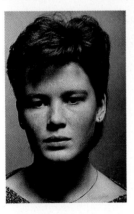

A high single floodlight used here to narrow the face and soften a square jaw line. Make your lighting fit the subject; don't expect every face to suit your favourite lighting set-up.

Lady in black (opposite) A lady of character. I asked her to kneel on a chair, arms resting on the back and leaning into the camera. The low camera angle is sympathetic to her strong personality and the black jacket provided a strong black mass which did not distract from the face.

Choose plain colours for portraits. I prefer black. For this picture, the lighting is daylight. There is a large silver reflector on the floor filling in the shadows under the eyes and nose.

131

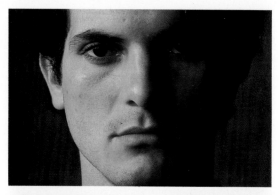

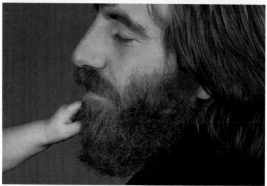

The studio portraits on this spread were all contrived well before the shooting session. It is a great comfort to have a picture in your mind before entering the studio.

Julian (above)
The bearded man and the baby's hand make an appealing picture, both masculine and soft.

The bold crop (top)
Using a 300mm lens has flattened the young man's features, making the face broader and stronger than if shot on a 105mm lens. The side light adds to the masculine atmosphere.

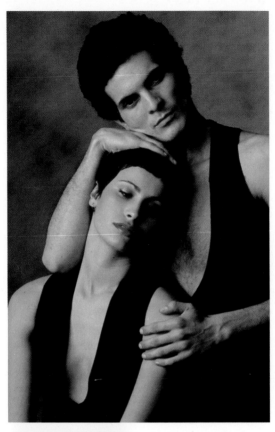

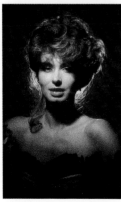

A controlled, planned portrait for a fashion magazine (above). Matching waistcoats and haircuts, combined with the composition, have resulted in a unisex image.

A spotlight plus a backlight (left) with a soft-focus filter and 3Ms 1000 film have produced a soft, romantic and glamorous portrait.

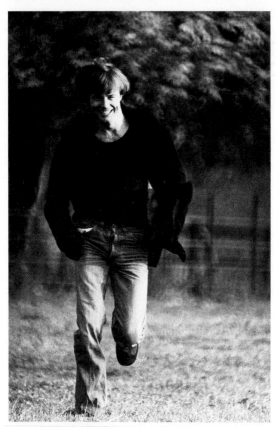

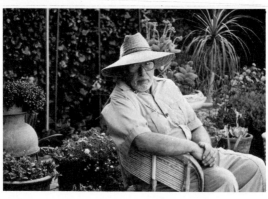

There are three basic styles of photographing people.

1. The candid picture in which the photographer is detached and unobserved by the subject.
2. The formal portrait, usually a studio picture, where all the elements of photography are controlled by the photographer.
3. The informal portrait in which the subject is aware and reacts to you in an informal surrounding.

To avoid facial distortion and emphasising poor features, change the camera position – for bald people, for instance, photograph from below chin level (*see* p. 131).

Talk to the subject to establish eye contact and ensure the eyes are in focus. Make sure the sitter knows you will be taking more than one picture, and that possibly several rolls will be shot.

Man running (opposite top)
I prefocused on a spot on the ground and had the model run toward the camera.

Environmental portrait (opposite bottom)
My friend Edward Sichel in his garden. Taking people in their favourite places always works.

Close-up face (below)
Using a 105mm lens, I cropped off the top of the head to compose right in the face. Concentrate on the eyes – the "windows of the soul" – so they dominate the picture.

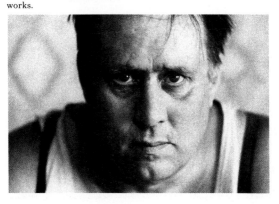

135

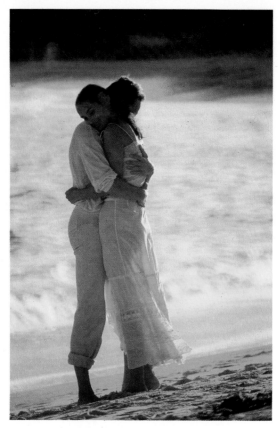

Lovers: vertical (above)
A planned shot for a travel
poster. The colours were
carefully co-ordinated. Even
the late afternoon light
(nearly sunset) was chosen
for its pink quality. A 500mm
mirror lens was used to
narrow the angle and
compress and simplify the
background. 400 ISO film
was chosen for its soft
contrast. The models didn't
require much direction!

Lovers: horizontal
(opposite top)
Another set-up shot. The key
to this photograph was
exposure. In reality the
picture was much lighter
with detail throughout. I
exposed for the highlights
and so turned the figures
into silhouettes which
seemed more romantic.

Wine growers (opposite
centre)
When shooting group
portraits, you need to forget
your own inhibitions in order
to entertain and keep the
attention of the whole group.

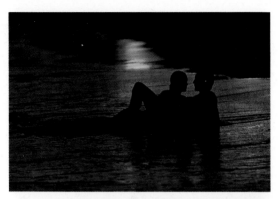

A commissioned portrait of an Antiguan chicken farmer. The picture wasn't going well until the children came out of school and saved the day. I used a tripod to give a focal point which enabled me to entertain the group.

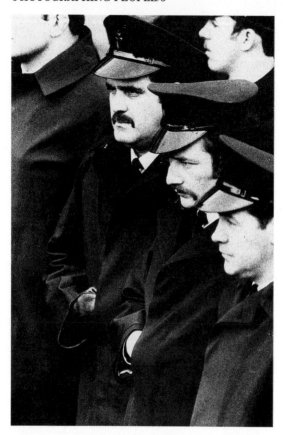

Reportage shot (above) of RUC police (hands on guns) taken during a tense IRA funeral in Londonderry. The 80–200mm zoom lens has enabled me to crop precisely from my fixed position to fill the frame with black and emphasise the two right arms.

Two clowns (opposite top) Photographing people unobserved sometimes requires waiting long enough to become "part of the funiture". I worked for three days backstage at the circus. At first everybody wanted to pose, but soon they got bored and the pictures improved.

This elderly French couple (opposite bottom) checked all the menus in a street of St Tropez restaurants. This gastronomic concern seemed specifically French to me. It's the sort of picture we take in foreign countries and probably ignore in our own.

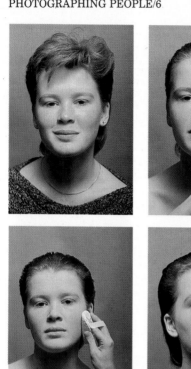

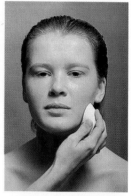

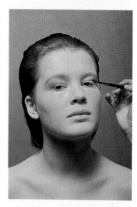

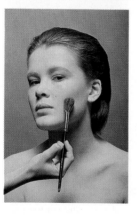

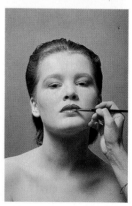

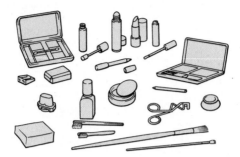

Ask if the model is allergic to any make-up. It is important for the model to take off any clothes such as polo necks that may smudge make-up. Use non-greasy moisturiser as it is difficult to apply foundation on greasy skin. Cover up blemishes before foundation is applied, usual places that need concealing are under the eyes and around the nose area.

You often have to mix 2 or 3 foundations to get the perfect colour. Use a damp sponge to apply the foundation, ensuring even coverage; pay special attention to the jawline, areas under the nose and around the hairline. Apply powder with a puff, with a firm, gentle rolling movement. Remember to brush off excess powder.

The series of pictures (opposite) shows the stages of applying make-up.

1. Base make-up: apply fluid make-up with damp sponge and concealer with a brush.
2. Always use a base as close to the natural skin tone as possible.
3. Using a sponge will give the smoothest texture, blend away down the neck to avoid a harsh line.
4. Use pencil on eyelid, blend the pencil up into the brow bone with a brush to define the natural shape of the model's eye. Make sure you choose a colour which complements the model's eyes and hair.
5. Apply a translucent powder over the face to dull down any shine. Use a blusher on the top of the cheekbones, lighten the top of the cheekbone.
6. Outline the lips first with a red pencil to define the shape. Fill in with a slightly lighter lipstick.

Glamour pictures rely greatly on the girl or man feeling great, so they can project a sexy, glamorous feeling. Therefore, a vital job of the photographer is to boost the ego – make the model feel great. Glamour photography is generally easier than that of nudes because by carefully choosing the clothes you can display the model's best features and hide the rest. The best glamour work is done in warm locations. A cold day in the park – forget it!

To take a shot of a girl with no clothes on is easy – to make a *good* nude picture definitely is not.

There are extremely few perfect bodies on this earth. The photographer's job is to pose (or suggest poses) and light the body to hide the faults and accentuate the good features. Remember that the body is an assemblage of round shapes and must be lit accordingly (*see* Lighting). The attention to detail of the still-life photographer is more appropriate to nude work than the glamour photographer's more extrovert style. It is important to study the mechanics of the body – what happens to the breasts when the arms are raised, what happens to the hip line when the leg positions change and so on.

The sensual nude.
The model has arched her back and her arms are behind her head. It is very important to study the mechanics of the body – every small movement has a dramatic effect on the form and the sensuality of the picture.

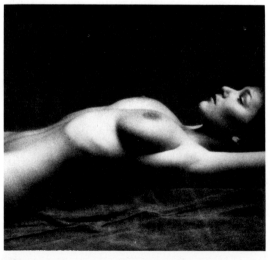

Nude as still life

This nude is shot almost as a still life. I have concentrated on the beautiful form of the female body and not its sensuality. The background is a continuous dove grey Colourama roll of paper (2.7m/9ft wide). I produced the mottled effect by spraying the background with dark grey pressure pack paint cans. The lighting was daylight from a large window. The light coming from behind the model has thrown the profile of the body into shadow, making a strong shape and providing mystery to the picture. Shot on 3Ms 1000 ISO film (colour) and a B&W interneg made. The resulting black and white print is very grainy and of high contrast.

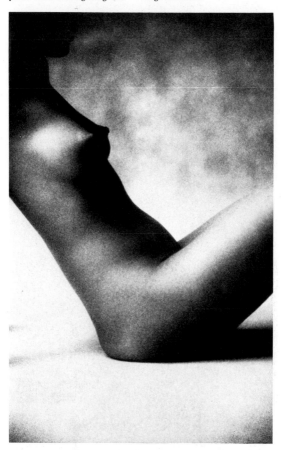

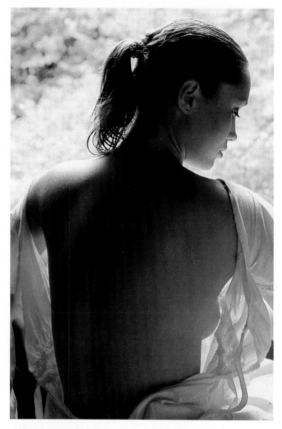

Window light: nude (above)
Lit from a normal size
window, ideal for nude
photography. The
combination of No. 1 Softar
+ KR6 filters has smoothed
and suntanned the skin. The
body is stretched to avoid
wrinkles.

Bikini on beach (opposite
bottom)
The body mechanics are well
applied here. The model is
stretched long and elegantly
with the left leg dropping
over the right to provide a
good hip line. She is
beautifully relaxed in the sun.

Nude
The colorama was sprayed with brown pressure pack paint. The soft brown atmosphere was created by combining a No. 1 Softar + 81EF filter, with Fuji 400D film pushed to 800 ISO. A high window light in a daylight studio was the only light source.

Spotted bikini
Long-lens shot of girl on beach, cropped for strong composition. Button pushed when she was in fine, flattering stance.

PHOTOGRAPHING CHILDREN

The secret of taking good pictures of your own children is to make photography just a normal part of family life. The camera should seem as ordinary as the telephone – not something special. Don't make photography into a big deal – if you fail today there is always tomorrow. If you build up tension today there may be no tomorrow.

The mechanical skills are very important when photographing children. The ability to follow frame and focus with a zoom lens (the most useful lens for kids) is important. You have to be totally

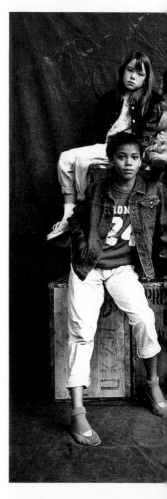

Group portraits of children (opposite) aren't the easiest of pictures to take. Daylight was the only light source. I drew a rough sketch of the picture and position of each child before they arrived. The children were easy to work with because they felt confident that I knew what I was doing. I had finished the shot before their concentration span lapsed – 15 minutes.

prepared before you start – camera, exposure set, lighting set and next roll of film at the ready. Children rely on you to give them confidence and reassurance; baby talk doesn't help. Be firm, polite and try to appear relaxed and unhurried. Remember, a child's concentration span is short.

Don't make taking a picture into a battle – if things aren't going well, forget it. It is only a photograph.

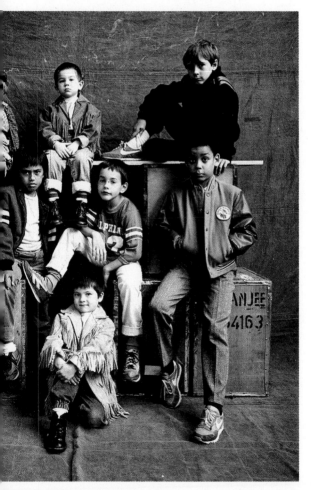

The lighting diagram and team used for this advertising shot. Left to right: mum, photographer, assistant with toys, mum of next baby ready.

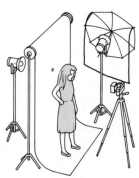

Bottoms up (opposite top) An advertising picture shot to a precise layout (see drawing above). I pre-lit the picture and made polaroid test shots to check lighting and exposure, using an assistant as a stand-in. I had 4 Nikons ready loaded. I booked 6 babies and tried manually to reproduce the art director's vision of the shot. By the time the 6th baby came on set, I was discouraged. But the mother insisted that her baby could make the required pose. To my amazement it went straight into position. I nearly missed the shot through loss of concentration – the vital ingredient in children's photography.

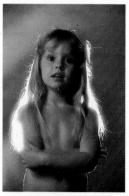

Illustration for a magazine article. I wanted an idealised "Pear's Soap" picture of a little girl. The backlight, through a hole cut in the background, has given her the angelic glow.

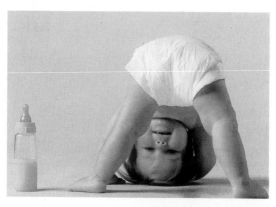

An exercise in colour co-ordination. My wife, Michelle, had photography in mind when she bought the jumpsuit and trumpet. We gave the trumpet to our son, Nicholas, when I was ready to shoot, so that his curiosity was at its height. Note that the lighting is from a broad, soft source, so that wherever he moved, the shadows stay soft.

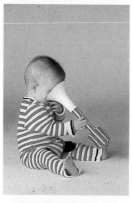

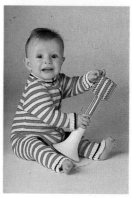

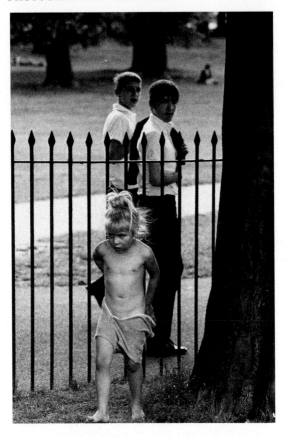

These are reportage pictures – glimpses into the child's world. It was a hot summer's day in Hyde Park, when I saw this little child go behind a tree to change. I knew there would be a picture on the way.

Nicholas (opposite top) in Hamley's Toy Shop. If a child is in an interesting environment, the photographer's job is much easier. A 105mm lens at f2.5 was ideal for the available light conditions.

First swimming lesson (opposite right)
One of the milestones in a child's life. I didn't use the camera until Matt was two-thirds of the way into the lesson, so as not to distract his concentration and also to ensure a genuinely unposed picture. Shot on an 80–200mm zoom, using HP5 (400 ISO) at 800 ISO. Keep a camera handy – the rewards are very personal.

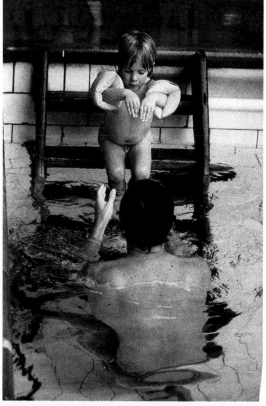

151

Nicholas with Mickey Mouse at Disney World. A quick snap shot with an autofocus Nikon compact – ideal when on holiday and you cannot carry heavy equipment.

Getting in really close (opposite right) to the flashing smile and pretty gold nose jewellery of which the little Sri Lankan girl was so proud. Shot on a 105mm macro lens.

I stood next to the judge in the middle of a competing ring of gymkhana riders (opposite left). The 300mm lens enabled me to "pick off" pictures of the children without attracting their attention.

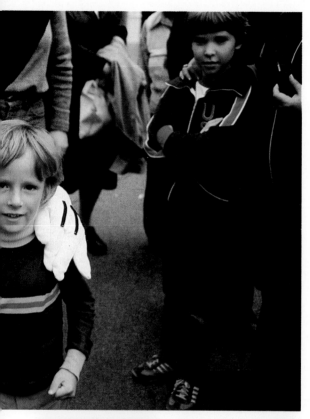

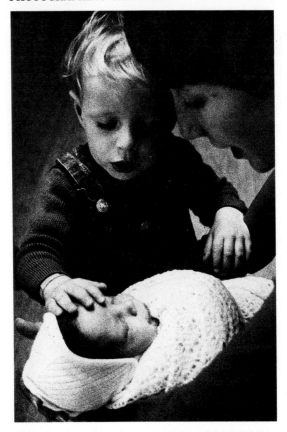

New arrival
The moment my son
Nicholas first met his
brother Matthew in hospital.
The shot is down to
anticipation and having a
camera with you at all times.

First step (opposite left) My
camera had been loaded and
ready for two weeks, waiting
for the inevitable first step. I
was ready when Matt finally
wobbled across the room.

Anticipating the historic moment

The most important thing to remember when shooting a historic event in your family life is to plan ahead.

You have to be in the right place at the right time.

You can't chase the action; you must be there first and wait for the action to happen.

Don't expect children to adapt to you, you must adapt to them.

If possible, avoid using a flash unit as you will call attention to yourself every time you try to use it.

Try and take photographs from a child's eye level.

Use high speed film and fast shutter speeds to slow down a child's exuberant movement.

First birthday (below right) An easy shot to anticipate, having the cake as a fixed position. Toddlers are totally unselfconscious with cameras, so it's a wonderful time for pictures. Don't miss out! Keep a camera loaded all the time when your children are small, otherwise you'll regret it. A photographic reord is so precious.

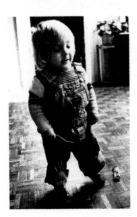 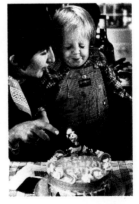

Remember that the wedding day is the most important day of many people's lives; so don't take on the sole responsibility of being the official wedding photographer unless you are extremely confident of your technique – both photographic and in managing people. If you are not the official photographer, take the opportunity to make an informal photostory of the *real* atmosphere of the day.

Informal checklist

1. Father pinning on his button hole.
2. Guests at the reception.
3. Presents.
4. Close-up of hands showing wedding rings.
5. The little flower girl with the bridegroom.
6. The bridesmaids.
7. The priest.
8. The cake.

And all those funny, spontaneous moments that make a special day a great occasion.

The bride and groom
Very important to take a good romantic close-up of the couple. This was a dark winter's day. 1000 ISO film handled the conditions well.

Bridal party
By checking out the locations the day before the event, you can plan your shots (such as the reflection in the lake). The 200mm zoom enabled me to shoot across the water. The same planning and attitude is required for christenings, barmitzvahs, graduations.

Check your checklist!

Check out the locations before the wedding – the church, bride's house and reception – notice places for camera angles, lighting and so on.

Shoot colour negatives, not slides, to make prints for albums and framing.

Use a high speed negative film. Its great latitude assures your exposure success and it permits fast flash recycle times on auto – important for fast, candid photography.

Take lots of spare film – you can always use what's left another time. Don't drink too much at the reception to keep a steady hand.

Equipment

Wide angle: 24- or 28mm for general scenes and groups. The wide angle allows you to work closer to the subject and in front of the crowd, thus not having to shoot over their heads.

Telezoom 80–200mm for the portraits and tight shots.

The 50mm normal lens for the low light shots.

Flash gun, "dedicated" if possible.

Tripod for groups.

Obtain permission in advance to use flash inside the church. If you get stuck in the crowd, stretch your arms and shoot over the crowd.

Use a wide-angle lens.

Take plenty of spare film (if you are inexperienced you will use more).

Get behind the scenes to take candid and unusual shots.

School sports day

The first thing to do when
planning to shoot a
photostory on sports day is
to discuss your plans with
the organiser well in advance
as no organiser has time on
the day. They certainly don't
want the surprise of you
popping up everywhere to
take shots unannounced.

To take good pictures of
any event, you first require
co-operation, so seek it
through the proper channels.

You need a programme
and must know exactly what
will take place during each
event, so you can plan in
your own mind the camera
positions. You cannot chase
the action all day – you must
be in position and wait for it
to come to you!

Mothers' race (above)
The one race to give the
children a good laugh. The
80-200mm lens is ideal for
this situation because you
can frame the picture all
through the race from the
finish line.

Trophy (opposite)
This champ was delighted to
pose for me after the
presentation. The 80-200mm
zoom again shot wide open
(f4) to throw the background
out of focus.

Boy sticking out tongue
(right)
There is always one in every
school! (I'm naming no
names.) It's the little
spontaneous pictures off the
action that add gloss to a
photostory. The 80-200mm
zoom has enabled me to
capture this rascal.

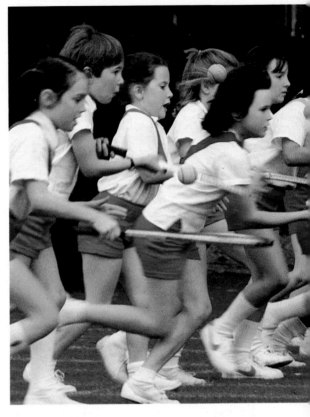

Start of race
Looking down the line, fill the frame with action. The zoom, set on approximately 150mm, has condensed the perspective. A 400 ISO film is required to allow you to stop down sufficiently to hold focus along the line (f11–f16 1/125th sec) – unless there is very bright light, of course. Always take some fast film, because in the late afternoon many events may be seen in shadow.

Be prepared to push the films to 800 ISO if required – there is no great deterioration in quality.

Tips
Plenty of film, including several 400 ISO.

An 80–200 zoom plus 28- or 24mm wide angle can do the whole job.

A motor drive is useful but not essential.

For running races, prefocus in front of the athletes and shoot when they come into focus.

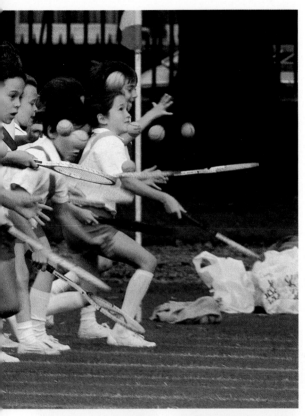

Mother and child on touchline
Everybody can't be Steve Cram. There are many wonderful, candid pictures at an event like this.
Remember, it's not all about the races and the winners.

Prize giving
I was amused by the height differential between the tall teachers and the small medal winners. The low camera emphasised this, and the 28mm lens allowed me to work close – in front of the crowd but low enough not to block their view.

A day at the beach can have its good sides as well as its bad sides. The richness of subject matter for the photographer is the good; arriving home with a camera full of sand and salt spray is the bad. A light coating of WD40 on the camera body (not inside and never on the lenses) and the tripod will give some protection from spray. Use an 81A or A1 filter to protect the lens.

A Kodak film bag containing a freezer pack will keep the films and equipment cool in the heat. It is also sand proof and will float if disaster befalls you. Wrap your equipment in a chamois leather inside the Kodak bag – if sand blows into it your equipment is safe.

The beach provides the same exposure problems that are encountered in snow. The bright light bouncing off the sand confuses the camera's meter into underexposure.

A polarising filter can be useful to separate the blues of the sky and sea, but don't dial in too much polarisation, otherwise a black sky is the result.

Don't leave your camera in direct sunlight: expansion and contraction will cause the lens elements to shift position and result in a loss of sharpness. When shooting colour prints or B&W, overexpose by 1 stop to be sure of good results.

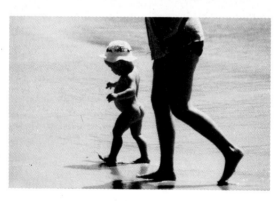

Protecting the camera on the beach

1. Use a waterproof and dust-proof camera like the Nikonos.
2. With ordinary cameras, use a Pelican-type, waterproof camera bag or seal the camera in a plastic bag.
3. Apply tape to all exterior exposed parts not in use such as flash synchroniser, motor drive terminals.
4. To protect your camera from spray, wipe the metal work with a swab of lint soaked in WD40.

Surf boat
Ideal colour slide film is 100
ISO E6 process film.

Surf carnival

To cover an event such as
this you must arrive early to
work out the logistics of the
day. A compass is useful to
work out where the sun will
be for each event. Discuss
your plans with the organiser
and ask formal permission
for photography. Equipment
is a problem. You require
telelenses and a heavy tripod
for many of the events; in
addition short lenses and
your zoom for the people and
surf atmosphere.

Split the shoot into two
parts. Ask for secure stowage
area in the club house. Use
heavy kit for events, then
change to lighter kit for
beach atmosphere.

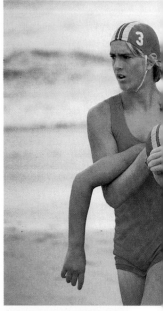

Long-shot beach scene
(above)
Shot on 400mm lens from a
cliff. The telelens has
compressed the busy scene
to make it look even busier. I
shot all the surf races from
this position. A high angle is
essential.

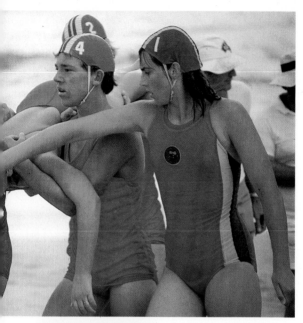

Life saving competition (above)

The image of clean cut, healthy Australian youth was shot on an 80–200mm zoom; the low angle adds drama. With light bouncing off a blue sea and white beach, it is advisable to use a warming filter to hold strong colours (KR3 used here). (*See* Filters.)

Veteran life-savers (above left)

The marching past of the ageing "surfies" was shot on a 300mm lens. It is easier to shoot action coming towards you on a telephoto lens from a distance.

Board rider (above)
The camera on auto has exposed the white spray, leaving the board rider in silhouette. (*See* Exposure.)

TRAVEL

Travel is the richest theme of all for the photographer because it includes all the aspects of photography: landscape, portraiture, still-life, close-up, underwater, architecture, children and even glamour and nudes.

In this section we will look at the logistical and technical problems that are inevitably associated with travel, and how these can be met in advance by good planning.

Check everything two weeks before the trip; shoot a test roll. Don't buy a new camera the day before departure. Pack spare batteries. Check that you have adequate insurance both for yourself and your equipment.

Take film with you, don't rely on buying in other countries. It is a nuisance and a waste of your time if you have to hunt round for a film stockist. Take more than you think you require; film is the cheapest item of the trip. The visual diary approach to travel photography – recording the bad times and the fun times – is as important as the grand landscapes.

Unusual conditions

Fog

This can provide wonderful conditions for pictures. Increase exposure by ½ to 1 stop as the bright glow of the fog causes the meter to underexpose.

Snow

Exposure meters expose for detail in the white snow, resulting in a picture of blue-grey snow. Overexpose by between ½ to 1 stop. (Bracket if possible.)

Lightning

Nighttime: Use a medium speed film – 100 ISO. Set aperture at f16, set shutter on B and lock the shutter open with cable release (the camera must be on a tripod). You can leave the shutter open for 4 to 6 minutes – long enough to catch a streak of lightning. Try having a strong shape in the foreground, such as a building.

Daytime: More difficult. Use medium speed film, stop down to f16. The length of exposure will be controlled by the automatic camera. Just keep exposing until you catch a fork of lightning on film.

Rainbow

Take exposure reading next to rainbow, not off the rainbow. Also, make an exposure at 1 stop underexposed, especially if the background sky is light.

Sunset

Beautiful, but can be difficult to expose. Take exposure reading from between 1 o'clock to 2 o'clock from the ball of the sun (12 o'clock pointed at the sun). Meter readings off the direct sunset cause underexposure to everything else in the picture.

Grey Days

Although grey, rainy days look at first sight depressing, excellent soft light is created for photographing nature, still-life and portraits. Compose pictures omitting the sky. Use 81A, A2, or KR3 filtration.

Good travel pictures come as a result of good planning. Research carefully to find out what festivals are going on and what seasonal spectaculars Mother Nature is producing during your holiday period. No matter how good your photographic technique becomes, in the end it is often *what* you photograph rather than *how* you take the photograph that produces interesting travel pictures.

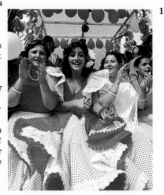

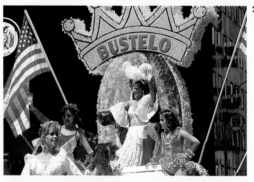

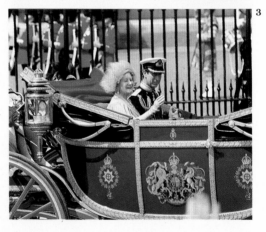

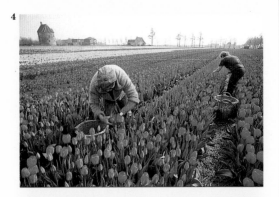

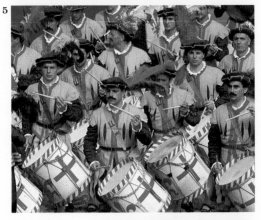

1 Flamenco festival, Spain.
2 St Patrick's day parade, New York.
3 Opening of Parliament, London.
4 The tulips of Holland in spring.
5 Calcio Storico festival, Florence.
6 Hunting season festival, Normandy.

Wearing the right clothes can be as important for taking a good picture as selecting the right lens. If you are too hot, too cold, too wet or the camera straps are cutting into your neck, you cannot concentrate on taking good pictures. One of the great problems for the travelling photographer is to travel light. I pack as for warm climates but add thermal underwear, socks and a cashmere rollneck sweater (light but warm). For extremely cold, wet conditions wear thermal underwear and socks next to skin, then a fibre pile suit (from climbing or skiing shops). The top layer should be a Gore-Tex jacket with hood, Gore-Tex trousers, waterproof gaiters, and waterproof

boots. Wear mittens that allow fingers to change films. A balaclava is warm and protects the face from "burns" off cold camera. Will also fold up into a hat. (*See* figure left.)

Keep your hands warm. In cold conditions the first loss of feeling will be in your hands. It is almost impossible to operate a camera for long in arctic conditions without suitable protection to the hands.

In severe conditions wear your gloves in layers: silk first, followed by a pair of woollen gloves and finally Helly Hansen mittens which allow the thumb and fingers to pop out for easy loading of the camera.

Adverse conditions

Cameras need constant attention if used in adverse conditions. Clean and maintain the equipment at night, when you have time and feel more settled.

Protect your camera by carrying it under your anorak; in hot weather keep both your camera and film cool: wrap them in silver foil and keep them out of the sun. In cold conditions cover all metal parts with gaffer tape, as cold metal can burn.

In cold weather, a useful tip is to strap a hand warmer to the back of the camera. It will stop the film going brittle and will protect your face from the cold metal.

You cannot change film in the rain. If you take three loaded cameras, it is possible to take a hundred photographs.

Use filters to protect the lens, especially in snow.

Rewind slowly in cold conditions; cold weather makes film extremely brittle.

Use silica gel packets to avoid condensation.

Keep cameras warm and dry, zipped up inside your jacket.

Never carry too much equipment.

Use a fisherman's sou'wester, worn back-to-front to keep rain off your camera.

171

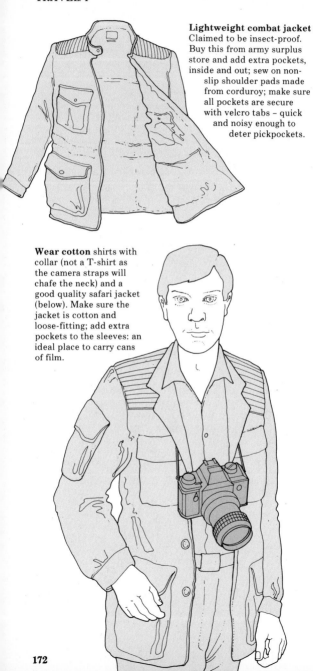

Lightweight combat jacket
Claimed to be insect-proof.
Buy this from army surplus
store and add extra pockets,
inside and out; sew on non-
slip shoulder pads made
from corduroy; make sure
all pockets are secure
with velcro tabs – quick
and noisy enough to
deter pickpockets.

Wear cotton shirts with
collar (not a T-shirt as
the camera straps will
chafe the neck) and a
good quality safari jacket
(below). Make sure the
jacket is cotton and
loose-fitting; add extra
pockets to the sleeves: an
ideal place to carry cans
of film.

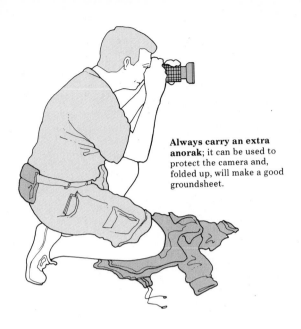

Always carry an extra anorak; it can be used to protect the camera and, folded up, will make a good groundsheet.

Keep all your documents and official passes in one pocket as they will be much easier to find.
Avoid jeans if possible; good quality cotton trousers with reinforced knees are available and will last longer. For wet and cold conditions, Harris tweed trousers are ideal as they are always warm and will dry quickly if wet.

A fisherman's waistcoat is ideal for hot climates; it has lots of pockets and net shoulders for extra coolness.

Hot sun can be dangerous:
1. Wear hats in hot climates or at least use high factor sun cream for the first few days.
2. Arrange generous sickness insurance.
3. Always carry a small first-aid kit with you, containing eye ointment, eye wash, eye drops, antibiotics, diarrhoea tablets, bandages and sticking plaster, water-purifying tablets, salt tablets, glucose sweets, travel sickness pills, insect repellent, needle and thread, iodine, scissors. Take precautions against tropical and Third World diseases. Tetanus is preventable by vaccination; yellow fever is transmitted by mosquito bites; hepatitis is preventable by injection; malaria is preventable by anti-malaria pills. Vaccination for these is necessary for most countries.

Frostbite and Exposure
The early signs are painless – just a tingling sensation, followed by numbing. The extremities (tip of nose, ears, fingers or toes) go pale, then waxy white, later a mottled blue and in the extreme, finally black, when the skin feels hard and stiffens.

The affected area must be warmed *slowly.* Handle affected tissues gently. Get patient into warm environment as quickly as possible. If colour does not return quickly, soak affected part in warm water (not hot). When frostbite is thawing out, the patient will feel extreme pain – good sign! Seek medical attention as soon as possible.

No hot water bottles! No smoking!

Heat Stroke
Caused by high environmental temperature or illness such as malaria. Beware also of heat exhaustion when suffering from diarrhoea or stomach upset in hot climates.

For heat exhaustion (usually from dehydration) drink plenty of fluids and replace lost salt (½ teaspoon to ½ litre water). Heat stroke is more serious. Take patient to cool environment, remove clothes, wrap in wet sheet, fanning until temperature cools to 38°C/101°F.

Medical and legal

In many countries it is illegal to photograph civil disturbances, roads, bridges and airports. In Iceland a permit is required to photograph nesting birds and generally it is frowned upon to photograph beggars. In most Third World and Communist countries the main civil airport is also a military base where strict security is applied.

Photographers who ignore these local laws are liable to lose their camera and film and most likely their freedom.

Always ask the advice of your embassy before visiting foreign countries.

In Europe there is no restriction on taking pictures in public places but there are laws of privacy which apply if pictures are to be used commercially.

If taking photographs of a person, which may be used commercially, make sure you obtain a model release form signed by the subject. This should be worded in such a way as to cover any eventuality, such as retouching. Pictures of people in public places can be used editorially, no matter how indiscreet the subject may have been. Events which are newsworthy are considered to be public property, as are pictures of film stars and celebrities who normally chase such publicity. Photographs taken in private places such as sports grounds, private houses, museums, the cinema and theatre are covered by local bylaws or conditions of entry; if you take pictures there you could be guilty of trespass and your equipment might be confiscated.

In some British art galleries it is not permitted to take photographs, but some European and American galleries allow photography for personal use only.

Make sure you read contracts carefully, and never deliver pictures without a delivery note with terms clearly stated.

Draft contracts and model release forms are available from the national unions which represent photographers.

Identify all pictures with photographer's name and a caption stating where and when the picture was taken.

Before visiting an exotic country, do as much research as you can. Customs and religions are very important, knowledge of them will save the embarrassment of offending the local residents. In exotic locations you must be self-sufficient, carry spare batteries, film, screw drivers etc. First impressions are important but don't over-shoot on the first few days – you may run out of film.

A captioning system is important: number the films and relate the numbers to map locations.

Check medical and legal requirements.

Hotel (above)
If photographing buildings while on holiday, it is helpful to include some of the surrounding areas to give the flavour of the country. This hotel is not a masterpiece but it looks very inviting set behind the pool. A polariser on a 24mm lens has dramatised the picture.

Mother and daughter (above)
I found the mother in the market place plaiting her daughter's hair. She was happy for me to take pictures. A zoom lens (35–105mm) is ideal to carry when walking around.

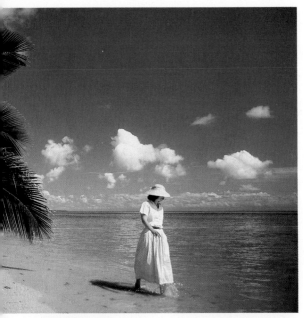

Flycatcher (above)
A carnivorous plant, unique
to Madagascar. I used a
companion's hand to provide
the scale.

Girl walking on the beach
(top)
The woman was travelling
with our party and I asked
her to walk the beach for the
picture. A polarising filter
has given good blues; a
28mm and a low angle added
to a pleasing composition.

Facade with fire escape
The details on this building
are unique. It's sometimes
more interesting than
photographing the whole.
80–200mm zoom.

**Be wary about lighting
interiors**: only light for
photographic necessity, don't
conflict with the architect's
original design.
The staircase (left) was lit by
natural daylight from the
glass roof.

PC Lenses (perspective control)
In shot A the camera has been tilted upwards
to include the top of the building. The 28mm
lens has made the verticals appear to be con-
verging. The PC lens has allowed the camera
to be kept perpendicular in shot B.

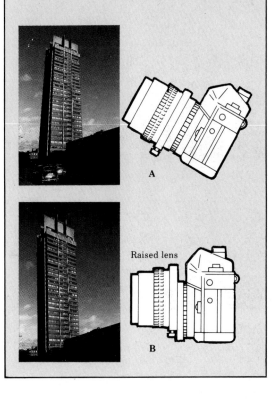

A

Raised lens

B

Photographing a city can be done in two parts. First, the big cityscapes – the classic views of the great cities – and second, the life and atmosphere inside the city.

The cityscapes need to be planned with the use of maps, guide books, postcards and a compass. With a map and compass you can calculate the best time of day to make your pictures. Postcards and guidebooks will advise you of what to look for and where to go. Always research your city trip before you leave home.

For the cityscapes you can take your full kit because you are going only to one set-up, but for the city reportage you need to wander the streets, so keep equipment to a minimum. Wandering around a city with one camera and three lenses plus a few rolls of film is therapeutic and rewarding. Trudging around with three cameras, six lenses and a flash is just hard work.

Barbados house (above)
The 24mm lens enhanced the sweeping staircase and the polarising filter darkened the blue sky.

Cityscape, New York
Looking up at the
skyscrapers with a 20mm has

exaggerated the perspective.
It's like being amongst
Manhattan's skyscrapers.

The serious wildlife photographer should avoid the smart lodge style safari. Safari camps are far more sympathetic to the country and the animals – and comfortable too. The safari camps in Kenya, like the Governess Camp in the Masai, offer a four-wheel drive vehicle with a good animal guide included in the price. Never attempt safari without a four-wheel drive vehicle. Never corner an animal for a picture – very dangerous.

Animals are at their most active early in the morning and late afternoon. You usually require fast film (400 ISO) because you are shooting on long lenses.

The more you know about animal behaviour, the better your chance to produce successful pictures. But the wonderful equaliser in photography is old Lady Luck.

Lemur (below)
A combination of a large aperture long lens (400mm f3.5) plus 400 ISO film pushed to 800 ISO has made the lemur picture in this dark Madagascan forest possible.

Using a hide

Excellent close-up shots of animals feeding and action shots of birds can be obtained from the refuge of a hide. On the larger safari and nature reserves permanent hides are often built.

The simplest type of hide is made with four stakes knocked into the ground and covered with a durable cotton or light canvas material, coloured green or brown to blend in with the background. Build your hide as quickly as possible; leave it for 24 hours to allow the animals and birds to get used to it.

Because of the long wait involved, the inside of the hide should be made as comfortable as possible.

When shooting nervous animals, and all of them are, think of the first shot as the only shot – the noise of the shutter will frighten them away. Study the habits of the birds and animals, so that you will be better able to anticipate their reactions.

A zoo picture
The long lens (300mm) is
right on the bars and shot
wide open (f4.5). The bars
have therefore not registered
at all.

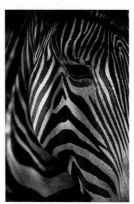

Shot in Kenya with 500mm
lens, but the type of picture
available at the zoo.

Photography in zoos is not going to produce stunning pictures of an animal's environment or behaviour, but it provides an excellent chance to take animal portraits. Zoos are improving greatly and the opportunities for photographers are good. Animal keepers can give advice on the behaviour of their animals, which may result in better pictures; so do ask.

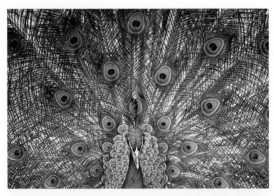

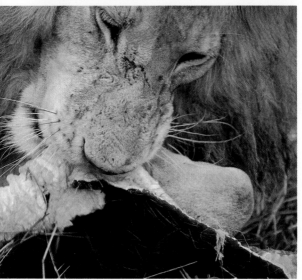

A scene in Masai Mara, Kenya, spotted for me by a great animal guide. I supported the camera lens on a bean bag (*see* tripods on p. 23). Concentration is vital: keep your eye at the finder and constantly adjust focus in order to be ready for the great picture.

Take photographs underwater and you enter into another world. Most underwater life is to be found in the first 10m/33ft, well within reach of the snorkel diver. But beware, the water is a hostile environment; if you are not a qualified diver, you must undergo training at a recognised diving school, you must never dive alone and you must always plan your dive.

An aqualung is essential if you want to photograph fish and wrecks. To lure fish, crack open some shellfish or a sea urchin and you will be amazed how quickly it will attract the fish.

Keep your photographic equipment simple to start with; both Nikon and Canon make good underwater cameras.

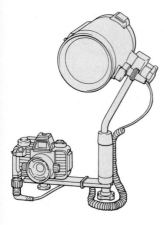

The Nikonos system
Designed to operate to depths of 50m/164ft, it consists of a waterproof, non-corroding, die-cast, aluminium alloy body. Water is excluded by the use of O-rings fitted to the lens, the inner body and control shafts.

The Nikonos has four lenses: 15mm, 28mm, 35mm and 80mm plus a set of colour correction filters. The electronic flash is auto exposure, dedicated to the Nikonos.

Lighting
Artificial light is necessary to show the full colours of underwater life.
At a depth of over 6m/20ft it is essential to use flash to restore colours lost in the water.
Bulb flash units are ideal for shallow water photography but below 10m/33ft they become unreliable.
Electronic flash units in an appropriate housing are ideal for flash photography at depth.

Checklist
Mistakes underwater can be fatal.
Never dive alone.
Never get so engrossed in photography that you forget where you are.
Always make a diving plan.
Wear an adjustable buoyancy lifejacket.
Beware of cuts from coral, always wear some sort of protective clothing.
Protect cameras from direct sunlight.
Light reflected from a sandy sea floor will give about one extra stop.
Get in close to the subject; the ideal distance is $\frac{1}{5}$ of total visibility (if there is visibility of 12m/40ft, shoot at 2.4m/8ft).
Use colour negative films – the results can be corrected.
Make sure you attach filters underwater as there must be no air bubbles between the filter and camera lens.
Restore colour balance with the appropriate filter – but experiment first.
Try 12 red colour units per 1m/3ft, so that at 3.6m/12ft you would use a medium strength red filter.
A good guide for exposure underwater is to open the lens by one stop below the surface plus an additional stop for each 3m/10ft of water.
If visibility is low, use a very wide-angle lens which takes you closer to the subject.
Keep the distance between camera and subject to a minimum and bracket exposures.
It is not necessary to dive deep to get good pictures; exciting photos can be obtained by floating on the surface and shooting down; use a rubber tyre for buoyancy. Don't forget that interesting life also exists in rock pools and rivers.

The greatest opportunities for underwater photography occur on reefs. Some of the best diving areas are in the Caribbean, the Red Sea and the Mediterranean. This picture was taken in the tropics on the Canon AS-6 all-weather camera, which is cheap, light, fully automatic and can be used to a depth of 15m/50ft.

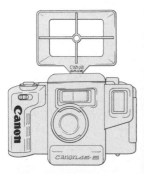

Sea walrus
One of those potentially wet and salty experiences where the new range of waterproof sports cameras (Canon AS-6 etc.) comes in handy.

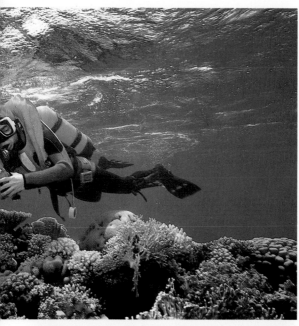

Nicholas diving
Shot in the hotel swimming
pool at midday (sun right
overhead) on auto (Nikonos
IV). Several attempts were
made for this picture.

Boy heading the ball
An example of peak action photography: the boy is neither going up nor down; he has been frozen at that split second before coming down to earth. A fast shutter speed is therefore not necessary (1/125 to 1/250 used here); with practice you can anticipate peak action.

Cricket match
Shot from the stand with 300mm lens + 1.4 teleconverter. Sit in the west stand, so the late afternoon sun is behind you and not pouring into your lens. A monopod is the ideal support. The better you know the particular sport, the better your pictures will be.

Shooting from aircraft
For aerial shots of the ground taken from a commercial aircraft, sit well forward or behind the wing, making sure there is a clean window. Use a shutter speed of at least 1/250th sec (1/500th or 1/1000th preferable), so you may require a 400 ISO film. Do not support the lens on the window because of plane vibration; throw a blanket or a jacket over your head to avoid reflections from the plane's interior disturbing the picture. Pan with the subject. An autofocus camera will try to focus on the window, so is unsuitable for this purpose. For shots of cloud formations and so on, it is fine to include wings in the composition.

Shooting from car, bus or train
Use a shutter speed of 1/500th sec (1/250th at least). Open a window if possible; if not, throw a jacket over your head to eliminate reflections and shoot *ahead* – before or after passing the subject but not as you pass by as too much blur occurs.

Customs
To avoid embarrassment at customs at home and abroad, make a list of your equipment for the customs and give it to them before leaving in order to prove on your return that you have not bought additional equipment.

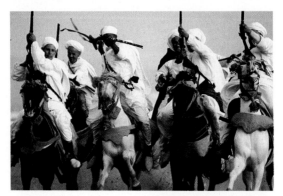

Charging Moroccan horsemen
The technique of pre-focusing in front of the action and shooting when the subject is in focus is essential for this type of picture.

Wind surfing
Sport is an opportunity to "pick out" shapes and patterns – look for the designs created by the action.

Two people splashing
The fast shutter speed has frozen the water in a way the eye is unable to observe. This shot: 1/2000th sec.

Existing light

With the fast film now available, photographs can be taken which would have been thought impossible a couple of years ago. Using natural light in pictures arouses a feeling of mystery which is impossible with flash. There are a few rules which must be remembered.

1. Artificial light can give a colour cast to daylight colour film; match the correct film to the light source or correct with filters.

2. It is possible to obtain a faster shutter speed or smaller aperture by doubling the speed of the film.

Reciprocity effect
With long exposures the reciprocal relationship between shutter and aperture breaks down, resulting in underexposure; this is called reciprocity failure. When shooting very long exposures, such as 3 seconds and longer, shoot extra exposures at double and double again.

Existing-light exposures for night events

Subject	ISO (ASA) 125–200	ISO (ASA) 320–400	ISO (ASA) 800–1000
Brightly lit streets	1/30, f2.8	1/60, f2.8	1/60, f4
Neon signs	1/60, f4	1/125, f4	1/125, f5.6
Floodlit buildings	½, f4	1/15, f2	1/30, f2
Skyline – distant view of lighted buildings	1, f2	1, f2.8	1, f4
Skyline – 10 minutes after sunset	1/60, f4	1/60, f5.6	1/125, f5.6
Fairs	1/30, f2	1/30, f2.8	1/60, f2.8
Fireworks – time exposure	f11	f16	f22
Stage shows	1/30, f2.8	1/60, f2.8	1/125, f2.8

The holiday photographer is often disappointed with the end result of his pictures, when the wonderful view he photographed ended up just a boring landscape picture. The problem is that the eye has the ability to flick around and gather features unconsciously to assemble them as a picture in the mind. Cameras can't.

The early morning provides us with most of our lighting effect. This was a foggy morning in Provence, France at dawn (below).

The other end of the day (bottom). The Buddhist monks were bathing at twilight. By exposing for the landscape the monks have become silhouettes.

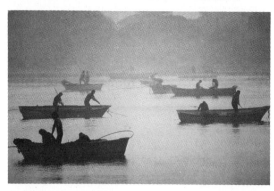

A good landscape picture *must* have a strong focal point – a dominant feature with a foreground leading to it and a harmonious background. The first inclination is to use a wide-angle lens to "get it all in". This often results in vague wishy-washy scenes that say absolutely nothing. Be selective. A telephoto lens often picks out a detail from a scene and can flatten the perspective to make a stunning landscape – very much a photographer's landscape.

But the magic element is light. The right time of day, a shaft of light from a stormy sky, or a foggy morning is what turns a nice landscape into a great one. To be at the right place at the right time requires effort and patience.

Finally, a good pair of boots, a warm coat and a pack of sandwiches are as important.

Landscape equipment

A heavy tripod is necessary and a spirit level enables you to take pictures that are level with the horizon.

Don't be lazy and photograph out of the car window; leave the car and move around looking for the best pictures.

Most photographers use a wide-angle lens for landscape. Try using a 300mm telephoto lens: you will be surprised how compacted the landscape becomes.

Get to know the weather patterns: take advantage of predictable weather and always go dressed for it – carry a spare anorak to cover the camera and tripod during rainstorms.

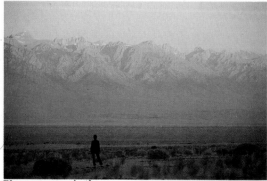

Place a person in the composition to provide a focal point and sense of scale if no natural features exist (above).

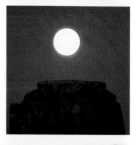

Monument Valley (right). This moonscape was shot at twilight. There was still sufficient daylight remaining to obtain detail in the rock and the moon. Shot on auto and bracketed. A 400mm lens has enlarged the appearance of the moon.

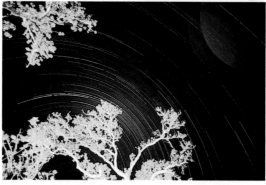

Star trails
I set the camera on a tripod with the shutter open on T (you can also lock the shutter open with a cable release on a B setting) and left the camera for 4 hours. The tree which appeared dark has exposed up to a bright green during that time. The slow shutter speed records motion that escapes the eye.

Some of the most exciting pictures can be taken after the sun has set. All pictures will need a tripod. Follow the chart below for the best exposure recommendations and bracket exposures if possible.

Subject	Film Speed	f-stop	Exposure
Star trails	ISO (ASA) 100	f4	10 minutes or longer
Meteors	ISO (ASA) 100 to 200	f5.6	30 to 60 minutes
Satellites	ISO (ASA) 200 & up	f4	Hold shutter open
Full moon	ISO (ASA) 100 ISO (ASA) 200	f8 f11	1/250 to 1/500 1/500 to 1/1000
Quarter moon	ISO (ASA) 100 ISO (ASA) 200	f5.6 f8	1/125 to 1/250 1/250 tp 1/500
Aurorae	ISO (ASA) 200 & up	f4	1 sec to 2 min, depending on brightness

New York skyline shot from the Staten Island Ferry. Half a second combined with the movement of the ferry has resulted in an impressionistic cityscape. The half second shutter speed gave the best result out of a range of shutter speeds that were experimented with.

Action photography isn't all racing cars and athletes: it is the right split second when you hit the shutter, before the peak of the action is reached – the smile, the wink, the kick or, as in this case (right) the reaching hand, that makes the difference.

Derby day at Epsom
I found the only man not interested in watching the races – the form guide. Use a film that will allow a setting of 1/125th to 1/250th sec at f8 and always have the camera focused at 2.4–3m/ 8–10ft. Then you are ready for an instant shot. Your observations of human behaviour get more acute with practice, but the camera technique also has to develop. The 28mm lens has stretched the perspective, making a more interesting composition.

This is a face that could have come from a 16th-century Florentine painting (right). We all feel shy when first approaching strangers for a photograph, but be comforted by the fact that you are performing a sincere act of flattery and most people, although shy, appreciate that fact. Shot on 80–200mm zoom at 200mm. The late afternoon light attracted me to make the picture. Shot during the Calcio Storico festival in Florence.

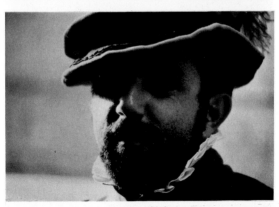

199

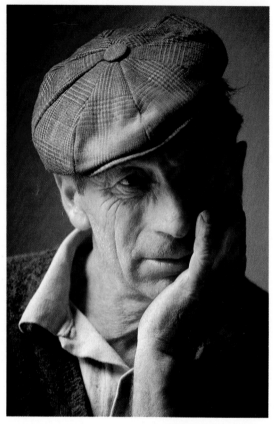

A portrait made across a crowded café in Italy. The window light on his faraway expression attracted me. I balanced the 300mm lens on my camera bag that was sitting on the table and focused. After the second shutter click he noticed me and gave a huge grin – I'd brought him back from miles away! The exposure was 1/30th sec at f4.5 on 100 ISO film.

A typical group travel photo (left). We were all off on a trip on this marvellous 1930s Madagascan train and a group shot for posterity was deemed essential. It's worth taking the trouble to set up the shots carefully.

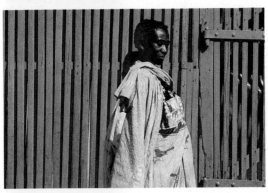

I found the blue background first (above) and waited across the street for the action to move into my picture. The woman's colouring worked well. This is a good way to work: compose first and wait for someone to hit the right position, then shoot.

The beautiful Isle of St Marie in Madagascar (left). A "getting away from it all" picture. I exposed for the background and shot on a 24mm lens with a polarising filter.

Close-up photography means focusing on detail and shape that you are normally unable to see with the naked eye. A world full of surprises.

The closer the lens works to a subject the narrower is the depth of field. Therefore, a great problem is having enough light to enable you to stop down sufficiently to hold focus through the subject. So the alternatives are either long exposures using daylight or tungsten or flash.

In the studio, tungsten or daylight are best because they are constant and you can see exactly what effect they are having on the subject. But in the open, a synchronised flash or hand flash (off the camera) are more effective because they will freeze the movement caused by wind and produce sufficient light to allow the lens to be stopped down.

The combination of a ring flash and macro lens is ideal for any close-up picture requiring a shadowless, descriptive light source. Beware, as the ring flash will reflect in any dark, shiny surface such as the eye (above).

Close-up equipment

One of the easiest ways to shoot moderate close-ups is to add close-up supplementary lenses. There is an acceptable loss of definition but no exposure adjustments are necessary. If the subject is backlit and the lens stopped down to f8–f11, loss of definition will be kept to a minimum.

For better quality pictures, extension tubes or bellows can be used. Extension tubes provide increased magnification in fixed steps. Bellows provide the best quality and are essential for the serious close-up photographer.

Normal lens with a close-up attachment; these are like screw-on filters and come in various magnification. They are designed to be used with the normal 50mm lens.

Macro lens – this is a better buy: designed to focus continuously from infinity down to a few centimetres.

Reversing the lens is possible with some systems.

Extension tubes can be bought in a set of three, each giving a different length.

Bellows used with a macro lens give the highest quality picture.

Butterfly on a flower
A teleconverter can be used
to get closer to the subject.
Here it has doubled the size
of the image (it doesn't
change a lens' minimum
focusing distance). The
butterfly was shot on a
105mm plus teleconverter.

Peacock feather
Peacock feather shot on a
105mm macro lens.
Remember your depth of
field becomes less the closer
you go, so for maximum
sharpness, keep the camera
on the same plane as the
subject.

Reversing the normal lens

To take a close-up picture without any accessories, try reversing your normal lens. Handle the lens carefully to prevent scratching. Hold the front of the lens securely against the front of the camera; to prevent light leaking round the edges, circle your fingers round the join. In reversing the lens you will lose diaphragm automation. If your camera is shutter-priority only, you won't be able to do this unless you can put it on manual.

The old penny (top) shot with a 55mm macro lens plus an M ring. The exposure factor was 2 (written on ring) requiring an exposure increase of 1 stop.

A 55 macro (above) plus K rings; the exposure factor was 4, requiring an exposure increase of 2 stops.

Two low glancing floods (right) diffused by tracing paper. The tripod central column is inverted. There is a white reflector opposite the light source and a black card on the lighting side to control the modelling.

Close-up techniques

Close-up is a generalised term, covering anything from a head and shoulders portrait to pictures the same size as the subject, known as 1:1 reproduction.

Macro-photography is a term used for pictures larger than subject size, up to a magnification of about ten times (×10 reproduction). Larger magnification than this is an area left to the microscope and endoscope; the term used is "photo-micrography".

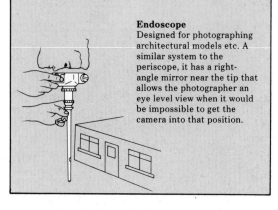

Endoscope
Designed for photographing architectural models etc. A similar system to the periscope, it has a right-angle mirror near the tip that allows the photographer an eye level view when it would be impossible to get the camera into that position.

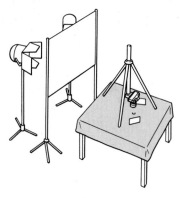

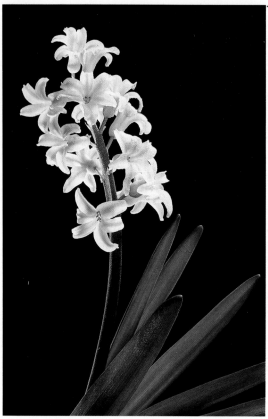

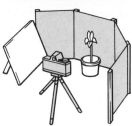

diffusion screens. The structure acts as a wind-break and light controlling system. You can place a diffusing screen over the frame also. The hyacinth (above) was shot with a black background on a 105 macro.

A frame constructed for outdoor photography of flowers and plants. It consists of 5 sharpened wooden poles with grooves cut in each side, to accept reflector boards (white one side, black on the other) or

Pencil sharpener (opposite top)
Shot on 105 macro with M ring and lit with a strong flood. The lens was stopped down to f32 and the exposures were bracketed. Use 50 ISO or Kodachrome film for maximum sharpness.

Close-up flash

Use a slow or medium-speed film with a small flash unit, cover the flash window with tissue to diffuse the light. If you can't use the flash on automatic, set it on manual and use the tables below.

Flash table for zoom and supplementary close-up lenses

Flash	Guide numbers		
Distance	40	60	80
25.4cm/10in	f19	f27	f38
38cm/15in	f13.4	f19	f27
50.8cm/20in	f9.5	f13.4	f19

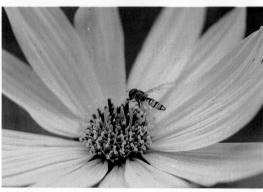

Yellow flower and bee
Shot on an 80–200mm zoom plus a close-up lens. Long lenses are best for insects – being further away you are less likely to startle them.

CLOSE-UP/5

The applications for copying flat artwork are numerous – copying and improving the old family portaits that have no remaining negatives, making captions for audio visual or holiday slide shows, or reproductions of paintings etc.

First it's essential that the camera and the flat art are square to each other and that the camera is mounted directly over the centre of the subject. Use a spirit level to check that everything is square.

The lights must be set at the same height as and 45° to the flat artwork, at a distance that gives an even coverage.

The lights must each have the same exposure value (see box on p. 211). Use an exposure reading off the grey card (see endpapers) to be sure of correct exposure reading. If the subject has a highly reflective surface, use a polarising filter or cover the lights with polarising gel.

Use slow, fine-grained films (Pan F or Panatomic X) but overexpose and underdevelop to reduce contrast.

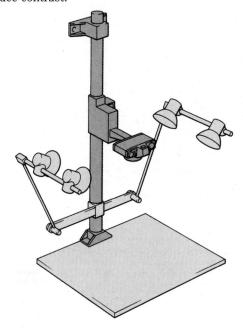

Restoring old photographs
Yellowish stains will disappear if a yellow fil-
ter is used with B&W film; old faded photo-
graphs can be revived with a yellow filter (it
increases contrast by lightening light areas
and darkening the dark areas). A blue filter
will increase contrast on B&W pictures,
while the yellow filter will work better on
sepia prints.
Faded parts can be enhanced in the dark-
room by giving them more exposure.

Use a pencil to
check the evenness of
lighting from two
lamps; the shadows
cast should be equal
in tone and length.

The Bowen copy stand
(opposite)
The camera is fixed on an
extension arm which will
bring it directly over the
artwork to be copied. The
camera can be moved up and
down the column. The four
adjustable lamps ensure
even adjustable lighting. It is
possible to adapt an old
enlarger for the purpose by
fitting a pair of lights and

mounting the camera in place
of the enlarger head.

**Collections of old
photographs** (such as the
locomotive above).
Restoring old photographs
with a copy stand is not
difficult. Holes and spots can
be retouched on the original
print. Any retouching will
have to be done with brown
tones rather than grey.

211

For magnification greater than 10× life-size or more, a camera attached to a microscope can be used. A special adaptor will have to be obtained to mount the camera body on to the microscope.

Keep lighting as bright and as constant as possible so that a fast shutter speed can be used. Initially, bracket exposure but keep records for future reference.

A single lens reflex camera with TTL (through-the-lens metering) is ideal. Special exposure meters can be bought if your camera doesn't have through-the-lens metering but they are costly and laborious to use. With a direct vision camera you will need a separate focusing device.

Always focus with the microscope focusing controls, not the camera controls and adjust exposure by changing the shutter speed, not the lens aperture. For lighting, direct the microscope lamp to the centre of the mirror and adjust the mirror until the field of view is evenly illuminated.

A simple adaptor fitted between your SLR camera and the microscope is all you need to photograph a secret world. Direct a light either at the mirror (for backlighting a specimen) or onto the slide (for front lighting a specimen).

Diatoms (above) and the **nerve motor cell** (right) were photographed with a bright field. The specimen must be cut thin. Light is condensed on the microscope concave mirror and beamed up so it passes through the specimen and fills the objective opening.

SPECIAL EFFECTS

Many special effects that used to take hours of meticulous calculation and execution can now be achieved by popping on a special-effects filter. The Cokin range, for example, is wide-ranging.

There are photographers who love special effects and those that consider them gimmicky and rather vulgar. Most of us go through a period of being fascinated by the visual possibilities of special effects and experimenting is important for the development of an understanding of photographic technique. Placing a filter holder in front of the lens is the first step of a carefully considered creative procedure. Start by looking through the viewfinder, try one filter, then another and compare the results. Gradually, you will begin to produce successful special-effect pictures.

Double exposure filter
The filter masks one side of the frame. I shot full frontal first and turned the filter mask round to the other side of the frame, then shot the profile. I used a black background. The lens must be stopped right down (f16) otherwise it can "see" around the mask. Multiple exposure can easily be made by shooting with a deep pile black velvet background. Make one exposure, then another over an unexposed area of the film (the black velvet will not have registered any exposure) and so on.

Cokin creative filters

Here are examples of creative filters that you will find interesting to experiment with. You can colour skies at will, make stars of light burst forth, create romantic moods and explore dream worlds.

Cokin filter

001 Yellow:	Intended for black and white photography. Accentuates clouds by darkening blue skies.
002 Orange:	Intended for black and white. Darkens blue and green – more dramatic on clouds than 001 Yellow.
003 Red:	Intended for black and white. Very dramatic, blues turn almost black – cuts through UV haze in distant landscapes.
005 Sepia:	Old-fashioned sepia effect.
020 (80A):	Balances daylight film to artificial light.
029 (85A):	Balances articial light film to daylight.
055 Star 16:	Turns all brilliant highlights into 16 point stars.
060 Centre Spot Indicolor 1:	Centre spot of picture sharp, makes edges diffused.
067:	As 060, but diffused edges are filtered blue.
082 Coloured Diffuser:	Soft focus effect.
092 Dreams 2:	Very diffused, dreamy appearance.
103 Close-up:	Supplementary close-up lens.
121 Graduated Grey:	Graduates from grey to clear. Darkens picture in grey area. Graduated filters are made in various colours.
151 Fog Filter 2:	Fog-like diffuser.
160 Neutral Polariser:	Cuts reflections. Colours more saturated. Blue skies darken.
198 Sunset 2:	Graduates from light to dark pink. Sunset effect at noon.
201 Multi 5:	Prism, producing 5 repeated images of subject.
342 Double Mask:	Masking filters, producing photo and montage in one shot.
397 Pre-Shape Frame:	Masks, giving shape of keyhole etc.

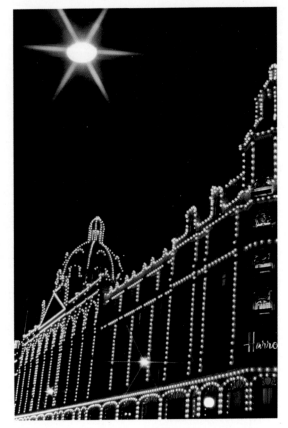

Star filter
The famous Harrods store at Christmas (above). The star filter has turned an ordinary old street light into the Star of Bethlehem, adding that Christmas symbol that makes the picture seasonal.

Spectra filter
The spectra X48 filter (by The B/W Company) splits spot light sources into a rainbow coloured circle (right).

Infra-red film

The red rose was shot on a conventional film. The green rose, the same flower, was shot on infra-red film. The colour and the exposure are unpredictable. Expose at recommended ISO ratings but bracket. Experiment with strong filtration. Note: you will find a different focus point for infra-red on your lens because it has a thicker film base.

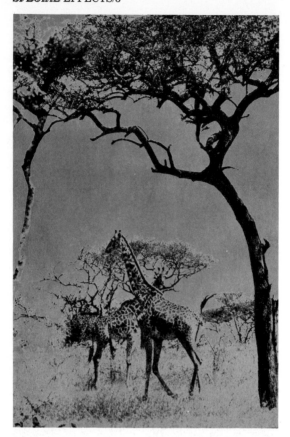

Solarisation

This is a very effective B&W special effect (colour also but more complex), made quite simply by re-exposing the print one-third of the way through the development either by a flash of the room light or with a torch and then developing up till a pleasing image is visible. The second exposure is actually reversing the positive print back into a negative. The resulting print is in effect half positive and half negative. You need to experiment with the strength and exposure time of the second exposure. There is no formula for perfect results, but it is great fun experimenting.

To superimpose two or more images on the same frame of film calls for a special technique – multiple exposure.

An obvious example is to superimpose the moon taken with a telephoto lens on to a normal (50mm) scene. You will need to decrease exposure so that more than one exposure adds up to the correct exposure time. If your camera automatically prevents you from exposing more than once on the same frame, try the following tip after the first exposure:
1. Hold the rewind knob on the top of the camera to stop it moving.
2. Press the rewind button on the bottom of the camera.
3. Stroke the film advance lever as you continue 1 and 2. Do not force the lever. If it works you are ready for the second exposure.

Harrods
Harrods department store was shot using a split-image filter. There are several varieties of these on the market.

Venice
This fog effect was produced
by simply huffing on the lens
– obviously not effective in
hot weather.

Complementary filters

Using complementary filters on the flash head and camera lens, it is possible to colour the background without affecting the fore-ground. Put an orange filter over the lens and the entire image becomes orange, but put a complementary blue filter over the flash head and the two filters will cancel each other out. The area that is lit by flash will now be normal, but the background which is unlit by flash will still be orange.

Stunning effects can be achieved by experimentation. Keep a record of each picture and build on your experience.

Clouds
This series of blue, orange and red clouds was produced by Spirotone filters that can be used either with or without a polariser. No polariser was used here.

Colour correction filters

Colour and tone go together; when applied to a shape they are the elements that give it solidity and substance. Colour transmits information about our surroundings; it creates mood and atmosphere. We register colour according to experience and association – a green tree in summer, a brown tree in winter.

Colour correction filters are useful when colour film balanced for one type of light has to be used for another. Type B colour film, if used in daylight, can be corrected by adding an orange (No. 85B) filter to the lens. Daylight-type film, if used with tungsten studio lamps, can be corrected by using a blue (No. 80A) filter.

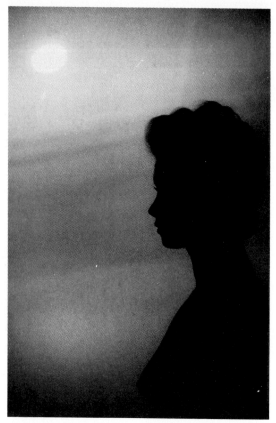

Girl and moon (above)
The girl was silhouetted
against a screen upon which
was projected an evening
moonscape.

Model (opposite top)
Strong backlight from a spot
behind her head has been
transformed into a halo
effect by a No. 2 Softar filter.

Tennis ball (opposite bottom)
This was fixed to the
racquet. An exposure reading
was made to find an aperture
to complement a 2 sec
exposure, i.e. f22 shot on the
80–200mm zoom lens with
the player keeping absolutely
still. For approximately ½
sec of the 2 secs, the lens
was set on 80mm. Then
zoomed out to 200mm during
1 sec. For the last ½ sec the
lens was fixed on 200mm.

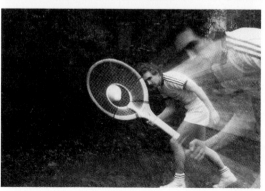

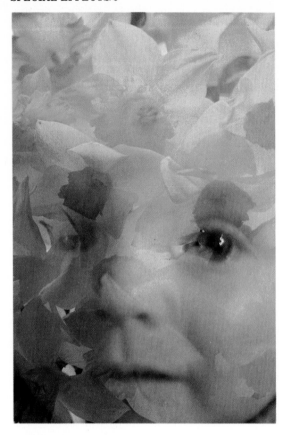

Double exposure (above)
Two exposures made on the
same frame, each
underexposed by 1 stop,
adding up to 1 correct
exposure (*see* Exposure).

Zooming (opposite bottom)
One continuous zoom from
80mm to 200mm through 1½
sec. This technique is also
effective on city lights at
night.

City light (left)
Nebular filter has created rainbow effect from the light point sources of the city.

Swans (below)
Effect created by the Nebular filter (by B/W Company) turning all brightly reflected light into the colours of the rainbow.

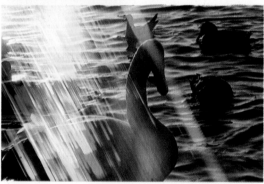

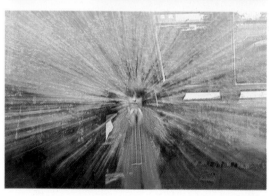

DUPLICATING

Duplicating transparencies can be a way of improving an existing picture or creating an entirely new image. A seriously underexposed transparency can be rescued by duplicating, as can a transparency with a serious colour shift.

The biggest problem with duplication is a build up of contrast. Kodak make a special "soft" duplicating film (low contrast) in both daylight and tungsten balance. By overexposing ½ to 1 stop and underdeveloping the film, the contrast will be reduced. This increase in contrast can be used creatively also. The creative potential of duplicating is enormous – e.g. double exposing two or more slides onto one picture, mixing black and white and colour, enlarging small portions of pictures and so on. Remember, too, with multiples you must halve the exposure for each slide; build up a stock of shots for duplicating – clouds, seas, suns, moons and silhouettes.

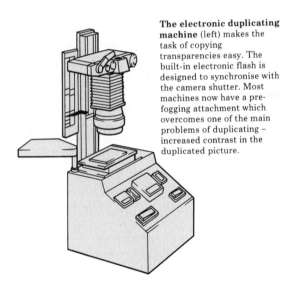

The electronic duplicating machine (left) makes the task of copying transparencies easy. The built-in electronic flash is designed to synchronise with the camera shutter. Most machines now have a pre-fogging attachment which overcomes one of the main problems of duplicating – increased contrast in the duplicated picture.

Most important, you must keep a notebook and record your technical details as you go along, to learn from your successes and failures and to be able to repeat the successes. B&W can be made on Agfa Dia-Direct Film.

A slide-copying attachment can be made by using a sheet of glass and a hand flash. Attach the slides to the camera side of the glass and mask all round. Make sure the flash head is strongly diffused.

The majority of camera manufacturers make slide-copying attachments which can fit on to the end of the bellows. To set up a system and to duplicate slides isn't cheap, simply photographing the projected image will not give you good quality. Even with one of these special attachments the results are not completely dependable. Make certain you are duplicating numerous slides before you commit yourself financially; in small numbers it's quicker and cheaper to have your slides duplicated professionally.

PROCESSING AND PRINTING

A consistently high standard of colour transparency (slide) processing requires a consistent use of films. It is best to build up a relationship with a good local laboratory (ask a professional where he has his film processed). Learn the correct terminology – the laboratory technician can be a good teacher. The effective film speed of all E6 process films can be altered by increasing or decreasing the time in the first developer. To increase is to "push", to decrease is to "pull". Films can be pushed or pulled in stages of 1/3 of a stop.

Pushing films increases contrast and grain size. Pulling films decreases contrast ("softens"). An underexposed transparency is called "thick" and an overexposed one is "thin". Kodachrome cannot be pulled or pushed.

Pushing warms the colour of E6 films and pulling cools the colour. The 400 and 1000 ISO (ASA) films can be pushed 2 stops, even 3.

A clip test is done on two or three frames from the beginning of the film to check that the film is exposed correctly. The rest of the film is processed accordingly. Professionals mainly clip test on a shoot of several films.

For chrome colour printing, the Cibachrome system is the best. You print from slides which are an ideal guide for your print ("reading" a colour negative requires considerable experience). The process is relatively simple, fine quality, inexpensive and most satisfying.

Black and white
Watching a good black and white print appear in the developer remains one of the great thrills of photography.

The word "darkroom" discourages many people from processing and printing their own films. In fact only the loading of the film into the tank requires total darkness – the remainder of the process can be completed with the room light on.

Printing has to be done under a darkroom safelight. The Patterson company makes an excellent matched range of everything required for the beginner (and expert), including developer, at a reasonable price.

Colour printing

Kodachrome films cannot be pushed or pulled and must be processed by Kodak or one of their agents. They are a good film to use if processing cannot be done for some time after exposure. After processing, Kodachrome is mounted by machine, and an electrically guided cutter separates the frames along the black line. If a photograph has an overall black background with an image which is off-centre, there is a good chance that the machine will centre the image incorrectly and cut through the middle of the picture. To stop this happening, cut the right hand corner by the address panel on the yellow pre-paid envelope and the film will be returned uncut.

Printing houses can provide good, cheap, machine-made prints from average quality negatives or transparencies. There are two types: first, R-types, which are taken directly from the original transparency. In the USA good quality R-types are available at many private print shops. The second type, Kodak C-type prints are best for quality; a negative is made from the transparency and the print made from the internegative. Most print shops offer a normal two day delivery service on this type of print.

It is more sensible to print from a transparency rather than a negative, as with a transparency you have a perfect colour guide; the colour balance can be corrected if necessary by referring to the original. A laboratory would also refer to the transparency when making a colour print.

As in taking a picture, colour printing is based on the principle of adding and subtracting complementary filters. You must be familiar with the principles.

RETOUCHING

Retouching may be divided into two areas – repairs and creation.

A dust-free, spotlessly clean darkroom and workroom would largely eliminate the necessity for repair work. White spots and hair lines that appear on the print are largely caused by dust on the negative. They can be spotted out, using photo dye diluted to exactly the density of the surrounding area. Use a fine brush and literally spot the dye onto the blemish – it can be painstaking work but after practice you really speed up. The same technique applies to colour prints, using colour dyes.

Black marks on the print are caused by pin-holes in the negative (see Film Faults); they can be scraped away gently with a scalpel. Any white areas produced can be spotted back again.

Negatives can be retouched by using soft lead pencils (B/W) to fill in light areas (dark on print) and reduce dark areas by either delicate scalpel work or potassium ferricyanide (bleach) on a cotton swab. Commercial portrait photographers often retouch negs to remove skin blemishes and generally flatter their clients (35mm negs are too small to retouch). Whole areas of the print can also be bleached with a potassium ferricyanide solution.

The talent of leading retouch artists is in great demand by advertising agencies. They add to the charms of photographs by blending together several pictures: the sky from one, the beach from another, the beautiful girl from yet another, to build up one stunning image.

A selection of equipment is necessary to retouch pictures such as the one opposite top. You will need: a palette for mixing dyes, air-brush for applying even tones, gouache for retouching prints, scalpel and brushes, photo dye (above).

Reproduction

The first time you see one of your pictures in print is a great moment! Being a professional means knowing what happens to your picture when it is submitted for publication. Always supply a transparency: although colour prints can be reproduced, printers prefer to work with original transparencies.

For black and white reproduction supply bromide prints; glossy plastic paper may flare under the lights of the process camera.

Printers prefer underexposed rather than overexposed transparencies; if the colour is there they can bring it out, if not it will end up looking like a picture from a holiday brochure. Make sure all transparencies are blemish free.

FILM FAULTS

Fogging
A white fog area on slides or colour prints is usually caused by exposure to light, either leaking into the back of the camera, or a light leak while loading the film into the developing tank or opening the back of the camera before the film is fully rewound.

Vignette
Vignetting around the corners of the frame is caused by either the wrong lens hood (too long) or by too many filters.

Thin negatives
Thin negatives (too light) are caused by either underexposure or underdevelopment. Under-development can occur when the developer is exhausted, too diluted, too cold, or, of course, too little time is given to the development process. It is possible to intensify thin negatives (there are several brands on the market). If there is no image on the film at all, it has either not been exposed (the numbers will still be on the edges) or the film has been dunked in the fix- or stop-bath instead of the developer (there will be no film number left on the edge). If the film is clear on one side and has an image right along the other side you probably had insufficient developer in the tank.

Drying marks on the film occur if films are dried too quickly – always use a de-watering agent in the water before drying. Clear "railway tracks" right along the film are caused either by grit when wiping the film before drying or by grit in the mouth of the cassette when shooting (these are difficult to retouch).

Partial exposure, with the remainder being black, is usually caused by the shutter not being synchronised with the flash, i.e. if the synchronised speed is 1/125th sec and the camera has been set on 1/250th sec. Dark negatives (too thick) or light transparencies (too thin) are caused by overexposure or by considerable overdevelopment. Overdevelopment can cause an excess of grain.

Hair
A single strand of hair can do untold damage to a roll of film if it lodges in the track in which the shutter runs. It can appear on and ruin every single

frame on a roll of film. If the hair is caught on the back of the lens the result will be the same.

Double exposure
If you change films in mid-roll, make sure you label the unfinished roll; there's nothing more annoying than exposing twice on a roll of film.

Rain
Water drops on the front of the lens act like small lenses and will distort the picture. They will be most noticeable on a wide-angle lens as individual drops, on a longer lens they will appear just as blurs. To prevent drops, use a UV filter or a big lens hood in inclement weather.

X-ray
X-ray machines at airports carry signs saying that they will not damage film – but they will. The faster films (1000 ASA) are more at risk. Don't bother to buy a lead, X-ray proof bag to put your film in: all the X-ray operator will do is turn the power up to look inside. Always carry your film through with you and explain to the security operators the problems. The effects of X-ray damage are immediately recognisable: colour transparencies and B&W film take on a hazy, milky quality.

Flare
A bright light shining directly into the lens can create rings of bright light on the picture. There will also be a loss of colour by overexposure. To prevent this happening, try a lens hood or shading the lens with your hand.

Picture unsharp
The blurring of a picture can have numerous causes. Camera shake is one of the beginner's problems. Always learn to hold the camera steady; below ⅓₀ sec only use a tripod and always try to use a fast shutter speed. Other less obvious causes are grease or condensation on the lens. Keep your fingers off the lens and protect it with a UV or neutral filter. Sometimes a close-up lens is left on, the lens may not be fully screwed into the body or in the worst possible case, the lens cap hasn't been removed!

Great photographers have the ability to see and isolate great pictures. Whether it is grabbing opportunities as they appear or arranging details in a studio – they all have a personal vision and a "great eye".

The first step in learning to be a great photographer is to study the work of other masters, Ansell Adams, Bill Brandt, Ernst Hass, Art Kane, Henri Lartigue, Irving Penn, to name but a few. Understand and analyse why a particular shot was taken, where the light was coming from, what compositional elements make it work, was it contrived and "set-up" or the work of a moment as various visual elements come together. Study deeply the lens technique and film used, make sure you understand all the mechanics of the photographer's art, and, above all, have enough enthusiasm to wait all day, if necessary, to get a particularly good shot.

Most of the photographs taken each year are taken only at Christmas and during summer holidays, which is a pity. Don't put away your camera after the holiday duty is done, take it with you everywhere, ask yourself what is your primary interest? If the camera records your interest, good pictures will follow.

Most hobbies have their own specialist magazines. They always welcome pictures sent in by enthusiasts. If your pictures are good they will be published; this is the first small step on the path to becoming a professional photographer.

Training in the USA

Photographic education has been established for many years at numerous universities in the USA. There, you can take a full-time course which will lead to a degree. Most courses are multi-disciplined and combined with other subjects such as design or painting, art history or biology. Each subject is given a credit value of hours per week. To gain a degree, a minimum number of credits must be obtained.

The degrees available are bachelor of arts, master of fine arts and doctoral degrees in photography.

It is possible to train at a privately-owned school, specifically structured to train profes-

sional photographers. The courses are usually short and specialised. The other opening is at night classes, but whatever course you decide to take, at the end of it a potential employer is only going to be impressed by the quality of your photographs. Nothing else counts.

Training in the UK

The study of photography in Britain is somewhat different. Most courses are linked to the professional body representing photographers in commerce – the Institute of Incorporated Photographers (IIP), which was asked by the government to oversee all full-time courses. Photography has now been linked to art and design courses, most of which lead to the B.A. (Hons) degree. There are more than fifty such courses, usually over a period of three years.

There are also numerous vocational courses and part-time courses as well as evening classes.

At the end of any course you will have a portfolio of prints with which to impress any potential employer. Look for areas of photography which interest you, make a short list of people to contact and start writing!

GLOSSARY

Acetic acid A chemical used in stop baths to neutralise and stop development before prints of negatives are put in the fixer.

Agitation A means of constantly moving a print or negative so that fresh chemicals are kept in contact with the emulsion surface.

Air brushing Method of retouching photographic prints by the use of a fine high-pressure spray of ink. This method requires considerable practice and is not to be undertaken lightly.

Air bubbles Bubbles of air which attach themselves to the emulsion and prevent development. Agitation is the method used to remove air bubbles during processing.

Angle of reflection When light is reflected from a surface, the angle formed between it and the imaginary right angle to the object is called the angle of reflection.

Angle of view The largest angle possible between two rays of light passing through a lens which will give a photograph of acceptable quality.

Aperture A circular hole behind the lens of the camera which controls and regulates the amount of light passing through onto the photographic film. The size is controlled by the "f" number ring.

Aperture-priority camera A semi-automatic camera on which the photographer sets the "f" number (aperture) and the camera automatically sets the shutter speed. You can override the system in a number of ways if necessary. One way is to "bracket": using the ASA film speed dial, set at a higher and then a lower film speed setting and you will get a "bracket" exposure setting.

ASA The letters stand for the *American Standards Association*, which has recommended a way of classifying film through a speed system. Film manufacturers rate their film in terms of its sensitivity to light, e.g. 200ASA, 400ASA, 1000ASA. The higher the number, the faster the speed of the film (i.e. the light sensitivity). All ASA speeds are printed on the film cartridge and box.

Automatic lens A lens which stays at full aperture, whatever working aperture is set, until the picture is taken. This allows perfect focusing without affecting metered exposure through the lens.

Autowinder A camera which has the facility to wind the film on one frame each time the shutter is released.

Back projection A technique for producing outdoor scenes in the studio. An exterior photograph is projected onto a translucent screen to form a backdrop against which subjects can be photographed.

Barn doors Attachments for spot lamps and floodlights, used to control the direction and width of the light beam.

Bellows A light-tight folding sleeve between the lens and the camera, mainly used in close-up photography.

Bleaching A chemical process which converts the black silver image into a colourless image. It is the first step in sepia toning.

Bracketing The art of shooting a number of photographs of the same subject and viewpoint but at different exposures.

Bromide paper The paper-based light-sensitive photographic paper used for printing photographs.

B setting The symbol on the shutter setting ring denoting that the shutter will stay open while the shutter button remains depressed.

Bulk film With motor drive cameras it is cheaper to buy film in bulk.

Bulk loader A device for loading 35mm cassettes from bulk film cans.

Burning in A method of controlling small areas of development during printing. The addition of small beams of controlled light through the use of fingers or a dodger, "burns in" more exposure during enlargement printing.

Cable release A simple flexible cable used for firing the camera shutter. It prevents you from needing to touch the camera during long exposures and consequently reduces camera shake.

Coated lens Lens with a coated glass surface, which reduces lens flare.

Converging lens A lens which causes rays of light to converge to a point (*see* Convex lens).

Convex lens A lens which causes rays of light to converge to a point.

Daylight colour film A colour film to be used with a daylight light source.

Dedicated When a manufacturer produces a flashgun that makes auto TTL exposures with its own camera, it is said to be dedicated (e.g. Nikon flash with a Nikon camera).

Depth of field The distance between the nearest point and the farthest point which can be said to be in focus.

DIN Stands for *Deutsche Industrie Norm* and is a German system of rating film sensitivity to light. The system is being replaced by the ISO system.

Drying marks Scum marks left on negatives and bromides by insufficient washing during processing.

Dust off A compressed-air can that produces a jet of air, useful for cleaning dust off lenses etc.

Establishing shots In photo stories, an establishing shot is an overall scene that establishes where, what and who the story is about.

Exposure meter An instrument for measuring the amount of light necessary for a photograph. The information is used to set shutter speed and aperture size.

Extension tubes Accessories used in close-up work to extend the film–lens distance; provides magnification over × 1.

Filters Coloured gelatin or plastic discs which alter the quality of light passing through them.

Fixed focus Cheap cameras usually have this system, where the lens is fix-focused on a distance most suitable to the type of subject usually photographed.

Flare Light particles scattered throughout the lens and which appear on the photograph as distracting blobs of bright light.

Glaze A glossy surface on photographic prints which will enhance the deepest blacks of the image.

Highlights The brightest areas of the photographic print, represented by dark areas on the negative.

Hot shoe A metal plate mounted onto the camera to which the electronic flash is attached. The hot shoe electronically synchronises the flash with the camera when the shutter is fired – no cables necessary.

ISO International Standardisation Organisation; used instead of ASA or DIN to indicate film speeds.

Incident light The light falling onto a subject.

Incident light reading Measurement of the light source; the exposure meter would be turned away from the subject and pointed towards the light source.

IR or R setting Marked in red on many camera lenses, it indicates the change of focus position necessary for infra-red photography.

I setting Usually found on cheap cameras, "I" stands for "instantaneous" and gives a speed of around 1/60 sec.

Lenses Single or multiple collection of glass surfaces, all of which bend light. There are two types, convex which bends rays of light to converge to a point, and concave which causes rays of light to diverge from a point.

Lens hood An opaque tube, made of plastic or rubber which prevents unwanted light falling onto the lens and causing lens flare.

Motor drive A fast automatic rewind that resets the shutter automatically. Used for sports or sequence photography; it can take up to 10 frames per second.

PC lens PC stands for perspective control. The front elements of the lens can be shifted up and down or sideways to correct vertical and horizontal lines that have become distorted – used mostly for architecture.

Pull film To deliberately overexpose film and compensate by reducing the development time.

Push film To deliberately underexpose film and compensate by increasing the development time.

Reflector A material from which light can be reflected onto the subject. Crumpled-up baking foil stuck to a sheet of cardboard is a useful accessory.

Safelight Most photographic materials are insensitive to certain colours, for example orthochromatic film is insensitive to red so can be handled safely in a red safelight. Check all manufacturers' specifications.

Shutter A mechanical device for controlling the amount of time that light is allowed into the camera.

SLR Single lens reflex.

Speed The sensitivity to light of photographic emulsions. Films are given ASA, ISO or DIN numbers, which denote speed.

Stopping down Reducing the size of the lens aperture and reducing the amount of light passing into the camera. It will also increase depth of field.

Transparency A positive image on a film base called a "slide".

T setting A camera shutter setting indicating "time" exposure; the shutter opens when the release is pressed and closes when pressed again.

TTL or **Through the lens metering** This measures light passing through the lens for automatic exposure. With 60%/40% metering the exposure readings are taken in 40% of the viewfinder area. For the 80%/20% metering the area is 20%.

Viewpoint The position of the photographer and camera in relation to the object to be photographed.

Zoom lens An extremely useful lens with variable focus; you can literally "zoom in" on your subject without changing your own position.

ACKNOWLEDGEMENTS

To my wife Michelle for supplying her own pictures to fill my gaps.
To my sons Nicholas and Matthew for lively modelling when asked.
To make-up artist Joanna Jose and model Rebecca from the Profile agency for the make-up spread.
To Jean for typing the manuscript from my handwriting.
To Fiona at Tecno for lots of information.
To Robin Bell for some fine B&W prints.
To Garry Evans and the technical dept of Nikon for advice on new technology.
To Beatrice Frei for all her painstaking work in editing the new edition.

All pictures in this book were taken by John Garrett with the exception of the following –
Michelle Garrett, pages 1, 36, 68, 92, 112, 113, 129, 168, 193, 197, 204, 209, 216, 217, 219, 221, 225
Seaspot, page 188
Gene Cox, page 213
Artwork by Hayward and Martin, Mark Franklin.
Retouching by Roy Flooks.